Pierre-Auguste Renoir

LA PROMENADE

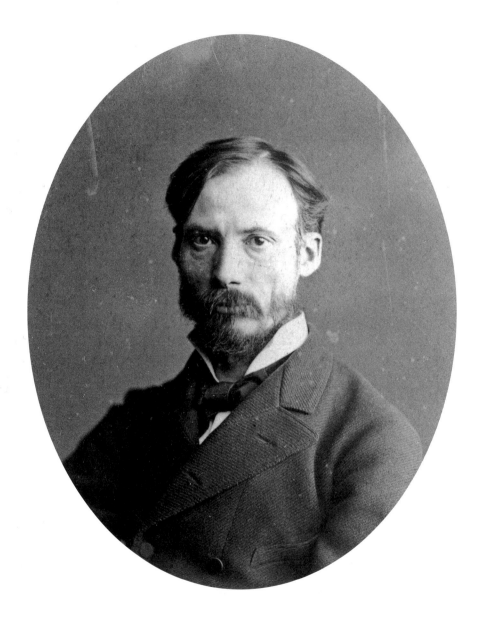

Pierre-Auguste Renoir

LA PROMENADE

John House

GETTY MUSEUM
STUDIES ON ART

LOS ANGELES

Christopher Hudson, *Publisher*
Mark Greenberg, *Managing Editor*

Gregory A. Dobie, *Editor*
Suzanne Watson Petralli, *Production Coordinator*
Gary Hespenheide, *Designer*
Lou Meluso, *Photographer*

© 1997 The J. Paul Getty Museum
1200 Getty Center Drive, Suite 1000
Los Angeles, California 90049-1687

Library of Congress
Cataloging-in-Publication Data

House, John, 1945–
 Pierre-Auguste Renoir : La promenade /
John House.
 p. cm. — (Getty Museum studies on art)
 Includes bibliographical references.
 ISBN 0-89236-365-7
 1. Renoir, Auguste, 1841–1919. Promenade.
2. Renoir, Auguste, 1841–1919—Criticism and
interpretation. 3. Impressionism (Art)—
France. 4. J. Paul Getty Museum. I. Renoir,
Auguste, 1841–1919. II. Title. III. Series.
 ND553.R45A73 1997
 759.4—dc21 97–21894
 CIP

Frontispiece:
Photograph of Pierre-Auguste Renoir, 1875.
Paris, Musée d'Orsay.

All works of art are reproduced (and photographs
provided) courtesy of the owners unless other-
wise indicated.

Typography by Hespenheide Design
Printed in Hong Kong by Imago

CONTENTS

Final page folds out,
providing a reference color plate of
La Promenade

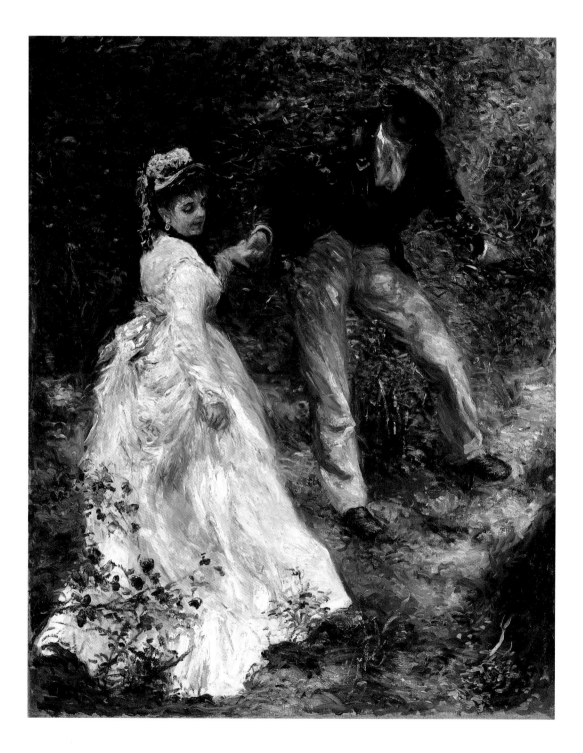

INTRODUCTION

At first sight, *La Promenade* [FIGURE I and FOLDOUT] is one of the most engaging and approachable of all Impressionist paintings. Dappled sunlight plays across a woodland glade; a young man pulls the foliage aside from a narrow path to allow his female companion to pass; she turns her head aside, perhaps momentarily hesitant to go farther into the woods. The technique—ebullient, variegated, informal—complements this scene of relaxed companionship and courtship. To late-twentieth-century eyes the work raises few questions and poses few problems; indeed, little has been written about it, despite its regular appearance in exhibitions and the Renoir literature.

Little is known about the picture other than the fact that it bears the artist's signature and the date of execution: "A. Renoir. 70." It is not clear where the canvas was painted or who its first owners were. The oil's first recorded appearance was at a Paris auction in 1898, where it was bought by the Impressionists' dealer Paul Durand-Ruel; first exhibited at the International Society in London in 1901, it passed through various private collections before being purchased by the J. Paul Getty Museum in 1989.[1] Even the painting's original title is not known. The work was sold in 1898 as *La Promenade*, but as early as 1941 it was pointed out that this may not have been the title that Renoir gave it.[2]

How, then, should we approach the painting? It would be easy to begin with what is known about Renoir himself—about his life and attitudes toward art. There is a problem with this approach, however. Many of the stories about Renoir and most of the accounts about his views come from his old age—from interviews conducted in the years before his death in 1919, particularly from conversations recorded by the dealer Ambroise Vollard and the remarkable reminiscences by the painter's son, the film director Jean Renoir.[3] By the early twentieth century, Renoir's opinions about art and society were firmly established; his loathing for mechanization and modern urban life was accompanied by a nostalgic appeal to traditions of artisanal craftsmanship. His accounts of his early career were viewed through the filter of these later concerns.

Figure 1
Pierre-Auguste Renoir (French, 1841–1919). *La Promenade*, 1870. Oil on canvas, 81.3 × 65 cm (32 × 25½ in.). Los Angeles, J. Paul Getty Museum, 89.PA.41.

I

The fragmentary evidence we have from Renoir's early career tells a rather different story. In the late 1860s and early 1870s he was a close associate of many of the painters who were posing the most radical challenges to the artistic authorities of the period. He was especially close to Claude Monet and was one of a group of artists that looked to Édouard Manet as its leader. Moreover, the subjects Renoir chose to paint suggest an active engagement with many of the central issues in the contemporary art world, specifically an acute awareness of the question of modernity in painting, of how the everyday experiences of modern city life might be transformed into fine art.

The present account of *La Promenade* will seek to restore the picture to its original contexts. Of course, in a literal sense this is impossible. The painter's original intentions cannot be reclaimed, any more than can the responses to the painting of its first—now-unknown—viewers. However, we can explore the frameworks within which the picture was made. How did Renoir's choice of this theme and the ways in which he treated it relate to the art of his contemporaries and to contemporary debates about the purpose of fine art and its role in society?

Here, though, the relevant contexts must be determined. Traditional histories of the period have viewed Renoir's early work, like that of his colleagues, as the beginnings of the history of Impressionism.[4] Such histories have examined the pictures primarily in relation to the central concerns that characterized the Impressionist movement as it emerged in the mid-1870s: an informal and seemingly spontaneous way of painting, and a concern with effects of outdoor light and atmosphere. In accounts like this, the relevant context is largely confined to the activities of the group to which Renoir belonged. The artists are presented as a self-contained avant-garde, whose primary point of reference was the art of their colleagues.[5]

Views such as this are anachronistic, more appropriate to the discussion of artistic groupings in the twentieth century, when the institutional structures of the art world changed and the notion of the avant-garde became securely established. Certainly, as will be shown, the artists of Manet's circle were viewed as a distinctive group in the late 1860s, but their distinctiveness was defined by comparison and contrast with other artists working in different modes. The paintings produced by members of the circle reveal their close and

active engagement with the same set of issues that faced artists with different values and affiliations. In the open forum of the Parisian art world of the 1860s, the paintings of fashionable artists were just as relevant to the form Renoir's art took as the paintings of his friends and colleagues.

The aim here is to bring out the issues that faced Renoir as he painted *La Promenade*. The other aspects of his work and that of his friends at this time will play a central part in this account, but the painting will be analyzed in a broader frame throughout. What did it mean to paint a picture like *La Promenade* in France in 1870, in the final months of Napoleon III's Second Empire? Instead of beginning with the artist and proceeding toward the picture, this study will start with the picture and only at the end ask what it reveals about Renoir as a man and artist.

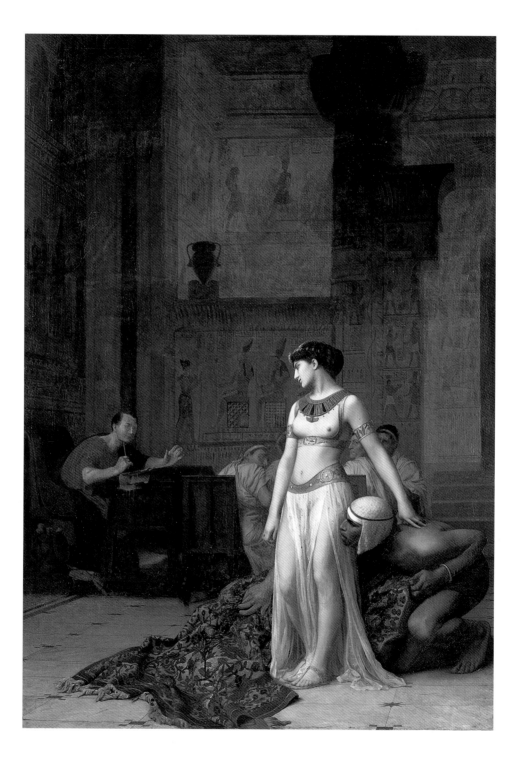

THE SALON AND THE ART TRADE:
GENRE PAINTING AND THE VALUE OF ART

For young French painters in the 1860s, the annual Paris Salon was by far the most important showcase for their work. Critics' reviews of the Salon offer the most significant commentaries on contemporary art in nineteenth-century France. At the same time, though, alternative outlets for paintings were rapidly emerging, particularly through the growing number of art dealers in Paris. Renoir regularly submitted his most ambitious pictures to the Salon in these years; he had two paintings accepted by the jury in 1870. *La Promenade*, however, was not intended for the Salon. Although the work's early history is unknown, the likelihood is that Renoir painted it in hopes of a sale through a dealer.

The Salon served two radically different functions. This government-organized event was intended to present the most elevated forms of contemporary art—art that tackled significant themes, such as morality or heroism, and treated them in a sufficiently generalized way to raise them above everyday reality. But the Salon also served as a marketplace; many of the pictures shown there were designed to attract private collectors, whose tastes, most commentators agreed, were for genre paintings—for trivial, familiar subjects treated in a meticulously illusionistic technique.

The popularity of genre painting went back a long way—to the medievalizing "troubadour" scenes of the early years of the century and to the spate of paintings of peasant subjects from the 1820s on, ranging from the idealizing Italianate figures by artists such as Léopold Robert to the humble French scenes of Adolphe Leleux and, later, Jean-François Millet. By the 1860s even academically trained painters such as Jean-Léon Gérôme were treating historical subjects in anecdotal, semihumorous ways that critics saw as more appropriate to genre, as in *Cleopatra and Caesar* [FIGURE 2], shown at the 1865 Salon. Another academic painter, William Bouguereau, had virtually abandoned mythological and religious subjects—because they were so difficult to sell—in favor of idealized peasant themes, such as *The Rustic Toilette* of 1869 [FIGURE 3].[6] In 1867 most of the medals awarded at the Paris Exposition Universelle were given to

genre painters, and in 1868, for the first time, a genre painting was chosen for the top award at the Salon: Gustave Brion's *Reading the Bible: Protestant Interior in Alsace* (present location unknown).[7]

The traditionalists' view of genre painting was vividly spelled out by the critic Olivier Merson in 1861:

> Genre painting holds sway over artists and dominates the public. It is a sign of the decadence of art. . . . The public is satisfied with the exact imitation of the form and color of clothes, furnishings, and accessories . . . and excuses artists from the rest—that is to say, from thought and great principles. It is no surprise that, finding a convenient path by which they can gain success and a reputation, painters commit themselves to this, without thought for the interests of art, determined above all to satisfy the picture dealers who seek to impose on them the whims of their clientele, which are more ostentatious than intelligent.[8]

For Marius Chaumelin in 1868, though, the triumph of genre painting was a cause for celebration:

> One can only applaud the decadence of mythologies and the decrepitude of symbolism, though we may regret that contemporary art cannot retrace the great events of history. But we console ourselves by the realization that the humble scenes of private life have never been reproduced with greater finesse and energy. . . . We can be proud of the importance that genre painting . . . has assumed in recent years. Do not these images of domestic life, these sketches of customs and characters, tell us the history of man himself? And is not this history as worthy of interest and as rich in lessons as the representation of empires bloodstained by war?[9]

The vogue for genre paintings that featured the lifestyle of fashionable, contemporary city dwellers was more recent. These pictures were first popularized in the late 1850s by the Belgian painter Alfred Stevens [FIGURES 4, 20] and after him by the Belgians Charles Baugniet [FIGURE 17] and Gustave de Jonghe [FIGURE 18] as well as French painters such as Auguste Toulmouche [FIGURES 5, 34]. By 1870 such meticulously painted images of women wearing

Figure 4
Alfred Stevens (Belgian, 1823–1906). *The Blue Dress*, circa 1868. Oil on panel, 31.9 × 26 cm (12⁹⁄₁₆ × 10¼ in.). Williamstown, Mass., Sterling and Francine Clark Art Institute, no. 865.

the latest fashions, generally presented in luxurious interiors, were common at the Salon; they also formed the stock-in-trade of a number of dealers, notably the highly successful Adolphe Goupil.

Renoir's own practice in these years shows an acute awareness of the status of different types of subject matter and of the ways in which artists were challenging traditional hierarchies. The examples of Gustave Courbet and Manet were clearly relevant to him, especially in the paintings he submitted to the Salon between 1867 and 1870. However, his oeuvre in these years, when taken as a whole, was very diverse; it cannot be seen merely as an offshoot of theirs. To place *La Promenade* in its wider context, we need to explore the range of references and comparisons that his art invited and the range of issues with which it engaged.

Figure 5
Auguste Toulmouche (French, 1829–1890). *Waiting*, 1865. Oil on canvas, size and present whereabouts unknown. Reproduced from a photograph published by Goupil and Co., circa 1867. London, Witt Library, Courtauld Institute of Art.

9

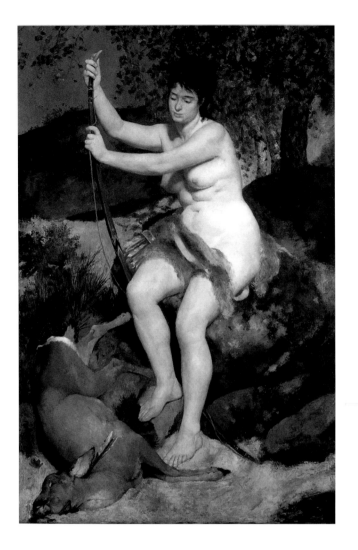

Many of Renoir's most ambitious figure paintings abruptly brought together traditional and overtly contemporary elements. *Diana* [FIGURE 6], rejected by the Salon jury in 1867, is a fusion—perhaps an awkward one—between the imagery of the classical goddess, with her attributes of a bow and a dead stag, and the fleshy, unidealized figure type familiar from the nudes of Courbet. In *Bather with a Griffon* [FIGURE 7], exhibited in 1870, a standing female nude, again reminiscent of Courbet, assumes a pose suggestive of the antique *Venus pudica*. Her hand shields her sex; her fashionable contemporary clothes are

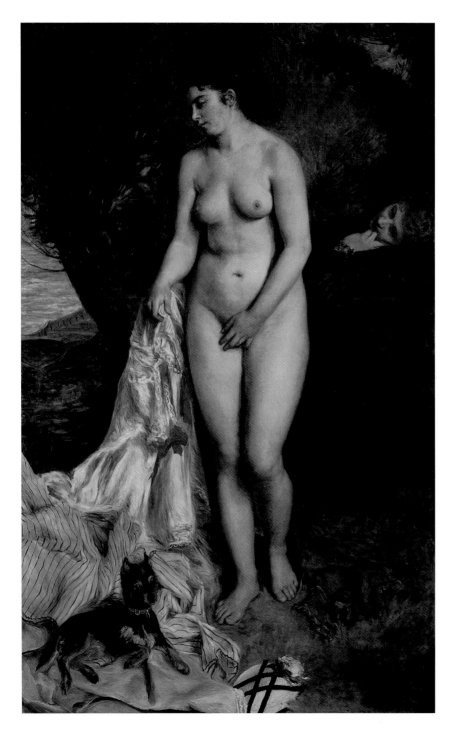

Figure 7
Pierre-Auguste Renoir.
Bather with a Griffon,
1870. Oil on canvas,
184 × 115 cm (72½ ×
45¼ in.). Museu de Arte
de São Paulo Assis
Chateaubriand, no. 95.

discarded beside her. The riverbank background and the presence of another woman echo Courbet's notorious *Young Women of the Banks of the Seine, Summer* [FIGURE 8], which was exhibited at the Salon in 1857 and again in Courbet's one-man exhibition in 1867. However, the notion of updating the subject of Venus by adapting poses from past art is closer to Manet's *Olympia* (Paris, Musée d'Orsay), with its clear echoes of Titian's *Venus of Urbino* (Florence, Uffizi).

Renoir's other Salon exhibit in 1870, *Woman of Algiers*, now known as *Odalisque* [FIGURE 9], invites a different range of comparisons—with recent Orientalist painting. The sensual pose is reminiscent of pictures by Jean-

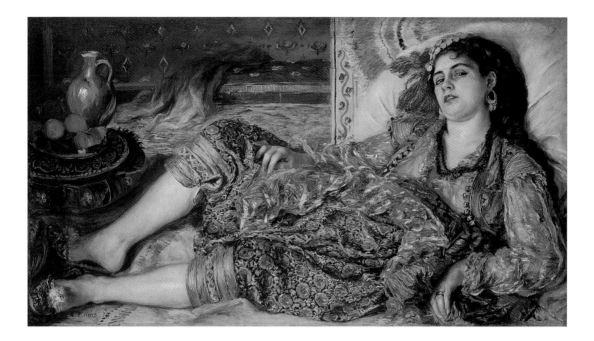

Figure 9
Pierre-Auguste Renoir.
Odalisque [*Woman of
Algiers*], 1870. Oil on
canvas, 69.2 × 122.6
cm (27¼ × 48¼ in.).
Washington, National
Gallery of Art, Chester
Dale Collection,
1963.10.207. © 1997
Board of Trustees,
National Gallery of Art,
Washington.

Auguste-Dominique Ingres, such as *Odalisque with a Slave* (versions in Baltimore, Walters Art Gallery, and Cambridge, Massachusetts, Fogg Art Museum), but the fluent handling and rich color echo Eugène Delacroix, especially his *Women of Algiers* of 1834 (Paris, Musée du Louvre).

Two other large early paintings by Renoir play on the same borderline between tradition and modernity. One of these, perhaps rejected by the Salon jury in 1866, is now known only from its appearance on the wall in the right background of Frédéric Bazille's *Studio of Bazille, 9 rue de la Condamine* [FIGURE 10].[10] In the work, a standing female nude, seen from behind, gestures to a fashionably dressed woman seated at her feet. Nothing is known of the early history of the other work, *A Nymph by a Stream* [FIGURE 11], in which a laurel-wreathed figure, reclining beneath some bushes, is presented as the personification of the source, with a spring of water issuing from between her fingers.[11] Both canvases invite comparison, again, with Courbet—the lost picture with his *Bathing Women* of 1853 (Montpellier, Musée Fabre), and the *Nymph* with his paintings of the late 1860s on the theme of the spring (for instance, *La Source* of 1868, Paris, Musée d'Orsay).

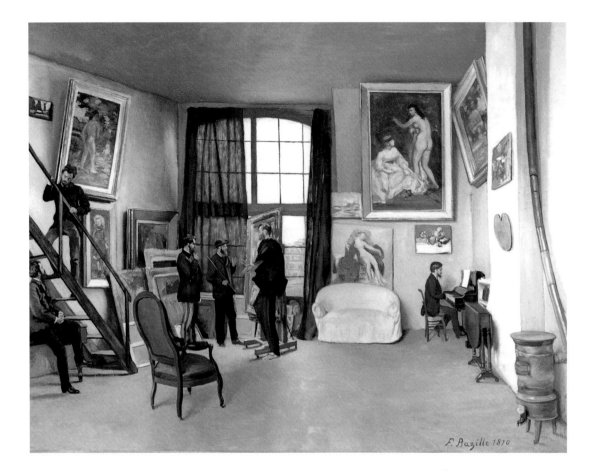

Figure 10
Frédéric Bazille (French,
1841–1870). *The Studio
of Bazille, 9 rue de la
Condamine*, 1870. Oil on
canvas, 98 × 128.5 cm
(38⅝ × 50⅝ in.). Paris,
Musée d'Orsay, RF 2449.

In all of these pictures Renoir followed Manet's example in another respect—he gave the figures individualized and clearly recognizable facial features, those of Lise Tréhot, his companion in these years. She was presumably the model for *La Promenade* as well.[12] In Courbet's nudes, by contrast, as in those of the academic tradition, the faces are generalized and typecast, thus distancing the figures from any sense of direct psychological engagement with the viewer. Only in *A Nymph by a Stream* did Renoir take this sense of engagement still further, by making the figure stare directly at the viewer, as Manet had in *Olympia* and many other canvases.

In this whole group of paintings Renoir's relationship to the traditions he invoked was anomalous. Certainly his fusion of overt modernity with

Figure 11
Pierre-Auguste Renoir.
A Nymph by a Stream,
circa 1871–72. Oil on
canvas, 66.7 × 122.9 cm
(26¼ × 48⅜ in.).
London, National Gallery,
NG5982. Reproduced by
courtesy of the Trustees,
The National Gallery,
London.

evident citations of the canonical exemplars of academic art could be viewed as provocative or even as parody. Indeed, Marius Chaumelin in 1870 explicitly described *Bather with a Griffon* as a caricature of the Medici Venus.[13] The parodic aspect of the paintings, however, is not as flamboyant as in Courbet's most provocative canvases, nor are the pictures as starkly confrontational as Manet's.[14] In relation to the work of the artistic grouping to which Renoir belonged, this might be seen as a marker of his relative conservatism, but, viewed in the broader context of debates about the future of public painting and the relevance to modern art of the art of the past, his wide-ranging attempts to harness elements from the past to an explicitly modern form of painting can be seen as an ambitious attempt at synthesis and reconciliation.

With their references to past art, these oils stood on the borderline between genre and mythological painting. Renoir also explored other possible ways of treating genre-like themes, at the Salon as well as outside it. His *Lise* [FIGURE 12], accepted by the jury in 1868, presents the virtually life-size figure of a young woman in a wood. Zacharie Astruc, a critic and friend of Renoir's, described the picture, which is on the scale of a court portrait, as a sequel to Monet's *Camille* (Bremen, Kunsthalle). This work, exhibited at the Salon two

Figure 12
Pierre-Auguste Renoir.
Lise, 1867. Oil on can-
vas, 184 × 115.5 cm
(72½ × 45½ in.). Essen,
Museum Folkwang.

years earlier, presents a life-size image of a young woman in a green dress. More surprisingly, Astruc saw Manet's *Olympia* as the starting point for both canvases.[15] Paul Mantz's general comments about the 1868 Salon relate particularly closely to Renoir's *Lise*. Criticizing artists for mixing the genres of painting, forgetting the laws of proportion, and treating trifling subjects on an epic scale, he concluded: "The anecdote has invaded everything; a particular play of light and shade has taken on the same value as a drama, and few artists still have the ambition to express a sentiment or an idea."[16] As will be seen, apart from the differences of scale, *Lise* bears a close relationship in thematic terms to *La Promenade*.

By contrast, in 1869 Renoir exhibited at the Salon a smaller, half-length figure titled *In Summer: Study* [FIGURE 13]. The picture's primary title links it to the familiar imagery of the seasons, but the subtitle emphasizes the work's informality.[17] Both the relaxed, inexpressive pose and the very broadly brushed background are a marked contrast to the treatment of *Lise* the previous year. At around the same time Renoir painted a more elaborate, larger genre scene, *The Engaged Couple* [FIGURE 14], but he seems not to have submitted it to the Salon jury. Perhaps this was because of the presence of the male figure, a most unusual element, as we shall see, in the modern-life paintings shown at the Salon. Here, too, some of the themes of *La Promenade* are anticipated, although its garden setting, indicated by the flower bed and the house at back right, is very different.

There is only one fragment of contemporary evidence about Renoir's attempts to sell his genre paintings in these years. In autumn 1869 he wrote to Frédéric Bazille: "I have put Lise and Sisley on show at Carpentier's. I will try to get a hundred francs out of him, and I am going to put my woman in white up for auction; I'll take what I can get for it—it doesn't matter." *The Engaged Couple* may well be the painting shown at Carpentier's; the "woman in white" is presumably *Lise* from the 1868 Salon.[18] At this time it was a common practice for an artist to put his own work up for public auction at the Hôtel Drouot in Paris.[19]

Marie-Charles-Édouard Carpentier had become the partner of the long-established dealer Armand-Auguste Deforge in 1856 and took over the business in the 1860s. Deforge had made a reputation from the 1840s onward for promoting *la peinture de fantaisie*, domestic-scaled genre paintings often inspired by Venetian art and the Rococo of the eighteenth century.[20] The fact

Overleaf:
Figure 13
Pierre-Auguste Renoir.
In Summer: Study, 1868.
Oil on canvas, 85 × 59 cm (33½ × 23¼ in.).
Staatliche Museen zu Berlin, Preussischer Kulturbesitz Nationalgalerie, A I 1019.

Figure 14
Pierre-Auguste Renoir.
The Engaged Couple, circa 1868. Oil on canvas, 105 × 75 cm (41⅜ × 29½ in.). Cologne, Wallraf-Richartz-Museum, WRM 1199.

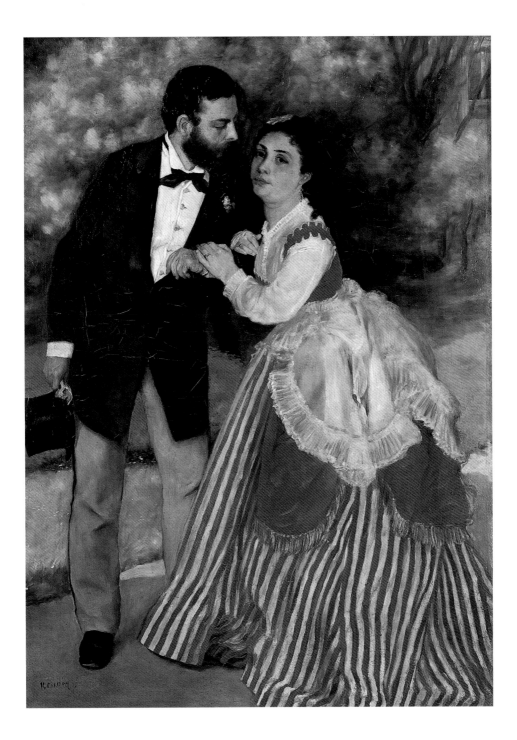

that Carpentier was interested in Renoir's art (as far as is known, alone of the Impressionists-to-be) provides another perspective on the painter's work at this period, for many of his compositions of the late 1860s and early 1870s, among them *La Promenade*, show a lightness and delicacy of touch comparable to the art of Rococo painters such as Fragonard.[21] Renoir had been a great enthusiast of French eighteenth-century painting since his early days as a decorator of porcelain. *La Promenade* would presumably have been the type of painting that he would have sought to sell to a dealer such as Carpentier.

The production and marketing of paintings like *La Promenade* belongs to a larger history, that of the emergence of the commercial art dealer as the primary outlet for smaller, domestic-scaled paintings. Although the Salon continued to be by far the most important means of attracting the attention of buyers, by the 1850s there were many dealers in Paris operating out of small shops and displaying an ever-changing selection of their stock in their shop windows. It was the window displays that led Théophile Gautier in 1858 to describe rue Laffitte, the principal art dealers' street, as "a sort of permanent Salon."[22] The Deforge/Carpentier shop was nearby on the boulevard Montmartre.

The advantages of showing smaller pictures in smaller spaces were described in 1861 by the genre painter François Bonvin, writing to Louis Martinet, the director of a gallery space that mounted exhibitions of contemporary art in the early 1860s:

> Yet another good mark for your idea of holding a permanent exhibition! That picture I brought you a week ago has just attracted the notice of the ministry to me. Placed in the big exhibition, where there are often many similar pictures, this canvas would not, perhaps, have been noticed. Intimate painting [*la peinture intime*], large or small, needs a setting like yours: larger is too large.[23]

It was difficult for an artist to sell his work to dealers, however, if he had not made a name at the Salon. Eugène Boudin's attempts to market his works during the 1860s provide insight into this problem. With luck, he might

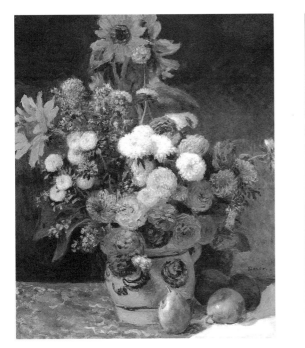
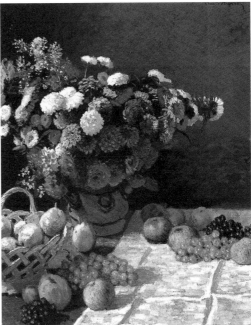

be offered fifty or a hundred francs a picture, but he would never go beyond this unless he gained a reputation that enticed one of the few major dealers to buy from him.[24] Renoir's hopes for a hundred-franc sale to Carpentier show that he was in the same position; what little is known about the sales that other Impressionists-to-be made to dealers in these years presents the same scenario. Pissarro, Monet, and Cézanne were selling the occasional picture to the modest dealer *père* Martin; for *The Seine at Bougival* [FIGURE 42], Monet remembered, Martin paid him fifty francs plus a small painting by Cézanne.[25] Presumably designed for sale through dealers, too, were the lavish still lifes that Renoir and Monet painted from the same bouquet of flowers, probably in the autumn of 1869 [FIGURES 15, 16].[26] Still lifes were especially marketable through dealers in these years.

In 1869 the dealer Paul Durand-Ruel opened new premises with gallery spaces intended to show paintings in their best light. He promoted his enterprise as an alternative to the Salon and to more aggressively populist dealers

Figure 15
Pierre-Auguste Renoir. *Mixed Flowers in an Earthenware Pot*, circa 1869. Oil on paperboard mounted on canvas, 64.9 × 54.2 cm (25½ × 21⅜ in.). Boston, Museum of Fine Arts. Bequest of John T. Spaulding, 48.592. Courtesy, Museum of Fine Arts, Boston.

Figure 16
Claude Monet (French, 1840–1926). *Still Life with Flowers and Fruit*, 1869. Oil on canvas, 100 × 80.7 cm (39⅜ × 31¾ in.). Los Angeles, J. Paul Getty Museum, 83.PA.215.

such as Goupil.[27] Renoir may well have seen galleries such as Durand-Ruel's as potential outlets for his work, but it was only in 1872 that Durand-Ruel began to buy paintings from him and only in 1881 that he became Renoir's primary dealer.

The politics of the Salon and the emergence of the dealer trade need to be seen in yet a wider historical framework, in the context of the last years of Napoleon III's Second Empire, specifically in relation to the notion of the "liberal empire" that he fostered in the late 1860s. The premiership of Émile Ollivier in January 1870 was presented as the realization of these moves toward political and social freedom, although the state retained considerable controls over political expression and the press. However, the relaxation of controls in the late 1860s did encourage the emergence of a vociferous republican opposition. This brief phase of active political debate was abruptly truncated by the outbreak of the Franco-Prussian War in July 1870 and the fall of the Second Empire in September.

In the art world, the organization of the Salon was also liberalized; new regulations for the election of the Salon jury in 1868 gave the vote to all artists who had previously had a work accepted. The landscapist Charles-François Daubigny was elected with the highest number of votes. In 1870 a group of artists opposed to the Academy drew up a list of artists whom they sought to have elected to the jury, including Courbet and Manet, but only two of this list, Daubigny and Corot, were elected, although with the highest number of votes. When the 1870 jury voted to reject Monet's submissions, Daubigny and Corot resigned in protest.[28]

Throughout the nineteenth century all images of contemporary life had a political dimension in the broadest terms. Any representation that claimed to show life as it was then lived was inevitably viewed in relation to the spectators' own visions of the social and political world. The gradual political emancipation of the late 1860s encouraged a more overt engagement with the political implications of such paintings. In his comments on genre painting in 1868 in the republican newspaper *La Presse*, Marius Chaumelin viewed its emergence in overtly political terms: "Genre is, above all, democratic painting, since it assigns the highest rank to the individual. Should we be surprised that it is growing so quickly and threatening to absorb the whole of art?"[29] However, the political and

ideological meanings of genre painting were more complex than this implies. The choice of theme was of central importance; the contrast between images of city and country was crucial. Likewise, the treatment of the subject—the rhetorical devices used to express its meanings—might transform its significance. The same subject might carry diametrically opposed meanings and associations depending upon the way in which it was presented.

In order to locate *La Promenade* in relation to these issues, we must focus more closely on its subject and treatment and examine it in the context of the range of alternative conventions current at the time, paying particular attention to the artistic, social, political, and ideological associations these conventions brought with them at this particular historical moment.

Reading Genre Paintings

The ways in which nineteenth-century viewers examined and made sense of paintings of contemporary life must first be explored. Through this, some idea can be gained of how the first viewers of *La Promenade*—whoever they were—would have approached it. What habits of viewing would they have brought to the picture? What meanings and associations might they have found in it? More specifically, the artwork and the devices it uses should be placed in relation to two points of comparison: the fashionable genre paintings in the Stevens/Toulmouche mode, and the provocative alternative posed by the paintings of Manet.

Viewers in the late twentieth century tend to look first at the general effect of a picture and to use their overall impression of it as the key to understanding its meaning. Scrutiny of details follows later, if at all. In the nineteenth century, by contrast, pictures were usually interpreted through a closer act of reading. Painters deployed a whole range of devices that, taken together, expressed the general idea of the image. These included the title of the picture; the grouping of the figures; their poses, gestures, and expressions; their clothing and attributes; and the setting in which they were presented. In reviewing the Salon of 1869, Jules Castagnary detailed the requirements of a successful genre painting:

> A feeling for functions, for fitness are indispensable. Neither the painter nor the writer can neglect them. Like characters in a comedy, so in a painting each figure must be in its place, play its part, and so contribute to the expression of the general idea. Nothing arbitrary and nothing superfluous, such is the law of every artistic composition.[30]

Paintings of the Stevens/Toulmouche type invited close reading of this sort. For instance, in Charles Baugniet's *Troubled Conscience* [FIGURE 17], shown at the 1865 Salon, the viewer is invited to imagine a whole narrative from the pose and expression of the seated woman, combined with the title of the

picture and the mythological scene—seemingly of Venus with cupids—on the wall behind her. Even where there is no such implication of a narrative continuing outside the space of the picture and beyond the moment depicted, the details of pose, clothing, and setting combine to characterize the type of figure depicted. Gustave de Jonghe's many paintings of mothers and children, such as *Preparing for the Ball* [FIGURE 18], use these devices to evoke the quiet joys of family life among the prosperous bourgeoisie.

Of course, pictures like these raise questions that go beyond what is depicted. The historian needs to explore the assumptions—both social and aesthetic—that lay behind the making and marketing of such works. The aim, however, was a form of transparency; artists sought to present images of a credible "real world," images that coincided with the viewers' notion of life as it was actually lived. In canvases like de Jonghe's, this is a self-contained world, seemingly presented in its entirety. In Baugniet's work, the viewer is not told exactly what is troubling the woman, but the indications in the painting leave little doubt that it is a question of sexual fidelity.

Paintings of this kind faced criticisms of various sorts. For traditionalists, as we have seen, the whole genre was a sad reflection of the triviality of the epoch, of the loss of values in everyday life as well as in art. Beyond this, particular pictures and painters might be criticized for the lifelessness of their figures, but such criticisms generally implied that it was possible to create lively, credible figures within this genre of painting. In 1870 the critic Théodore Duret, a friend of Manet's whom Renoir also knew by this date, condemned the works of Stevens's imitators:

Figure 18
Gustave de Jonghe
(Belgian, 1829–1893).
Preparing for the Ball,
1865. Oil on canvas,
size and present
whereabouts unknown.
Reproduced from a
photograph published
by Goupil and Co.,
circa 1866. London,
Witt Library, Courtauld
Institute of Art.

The woman in all these paintings is as far as possible from being a living being; she is a puppet or a mannequin whose purpose is to model the satin dress or the cashmere that is the principal character in the picture, surrounded by the vases and trinkets that decorate the mantelpiece or spread out across the table.

At the same time, however, Duret praised the truthfulness and vivacity of the figures in Stevens's own paintings:

26

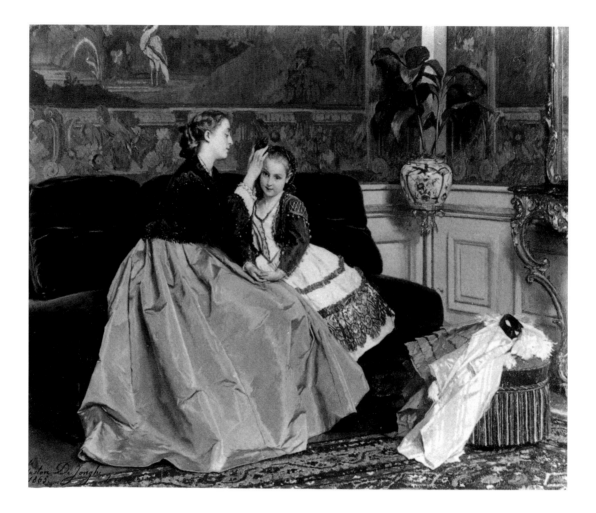

They reflect the image of the modern Parisienne, of that woman whose demeanor and toilette leave one not knowing quite what to think—hesitating to say a priori whether she is an honest woman or not.[31]

Criticism of paintings of this type could be extended into a whole-sale moral condemnation. L. Laurent-Pichat pursued this argument at great length in the republican newspaper *Le Réveil* in 1870:

Let us turn our attention to these likable young people who know so well how to dress themselves and how to wear a low-cut dress—to these idle society women who have nothing to do and whose little heads are filled with unhealthy dreams. For this art that is dressed up in silk and velvet is just as immoral as the nude art that we discussed a few days ago.

Looking at these women, "young, coquettish, preoccupied with mysteries, seductive, amusing, inviting," the critic kept asking: "Has she any children?" He imagined the women with their lovers while their husbands pursued honest careers.[32]

Comments such as these are part of a wider debate about the relationship between consumerist luxury and immorality that continued throughout the last years of the Second Empire. Fostered by anxiety at the licence of Napoleon III's court and the apparent triumph of the *lorette* (a high-class courtesan), this debate focused on the perceived impossibility of determining a woman's moral and sexual respectability from observation of her dress, appearance, and manner.[33]

In Laurent-Pichat's diatribe, as so often in reviews of these pictures, there is a constant and fascinating slippage between the discussion of the paintings and of the supposed "real world" they represent. It was their legibility and seeming transparency that made it so easy for viewers and critics alike to view them as unmediated. Instead of being recognized as value-laden fictions, they were frequently seen as unproblematic reflections of the social reality they purported to represent and were judged not as art but as an integral part of this social reality.

At the same time there was another, quite distinct form of critique of fashionable genre painting—articulated to some degree in art criticism, but

more vividly in painted form—in the work of Manet and his associates. The focus of Castagnary's comments about genre painting in 1869 was Manet's work, including *The Balcony* [FIGURE 19], which, as Castagnary pointed out at length, flouted his requirements for coherent, legible genre painting at every point: "He arranges his people at random without any reason or meaning for the composition." The poses and details in Manet's paintings quite failed to add up to a coherent reading; in *The Balcony* he had not indicated the relationship between the figures and what they were doing on the balcony.[34] According to Antonin Proust, Manet himself mocked the anecdotal reading of details that paintings like those of Stevens (a personal friend of his) invited:

> Alfred Stevens had painted a picture of a woman drawing aside a curtain [FIGURE 20]. At the bottom of this curtain there was a feather duster which played the part of the useless adjective in a fine phrase of prose or the padding in a well-turned verse. "It's quite clear," said Manet, "this woman is waiting for the valet."[35]

The motives behind Manet's dislocated compositions have been much discussed. The original viewers of the works had various ways of dealing with them. For the most hostile critics, they were simply evidence of the artist's incompetence. However, two other approaches help in focusing more clearly on the problems the pictures raised for viewers. One of these was to see Manet's paintings as a direct attack on the Toulmouche mode, and thence on the whole vogue for fashionable luxury, while the other claimed that Manet was concerned with color and touch alone, without regard to the subjects he was treating.

Manet's paintings, wrote Marius Chaumelin in 1869, "have greatly scandalized the lovers of neat, tidy, sentimental bourgeois painting"; they lacked "expression, sentiment, and composition." In 1870, in praising Manet's Salon exhibits, his friend Edmond Duranty made the opposition still clearer:

> Against refined, artful painting, Manet opposes a systematic naïveté and a scorn of all seductive devices. He places his figures against a dull slate gray background, as if he was puritanically protesting against the trompe-l'oeil curtains and the bric-à-brac furnishings that the greater and the lesser *toulmoucherie* . . . heap up for fear of being taken as paupers.[36]

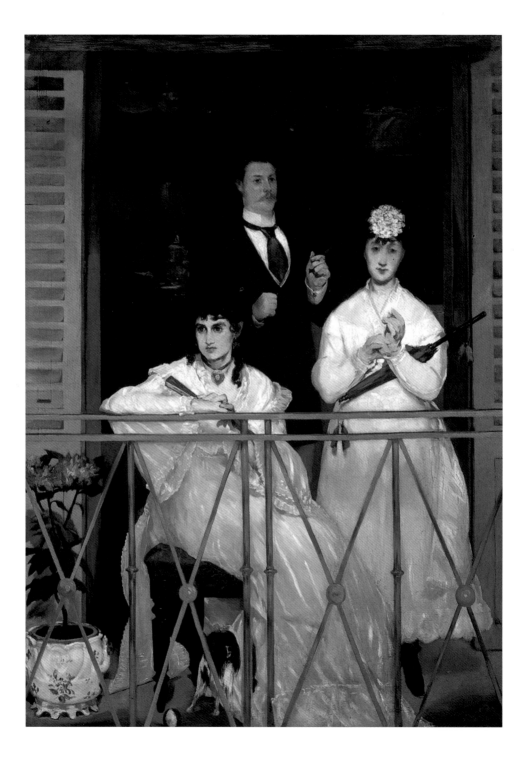

Figure 19
Édouard Manet (French,
1832–1883). *The
Balcony*, 1868–69. Oil on
canvas, 170 × 124.5 cm
(67 × 49 in.). Paris,
Musée d'Orsay, RF 2772.

Figure 20
Alfred Stevens. *The
Morning Visit*, circa
1868. Oil on canvas, size
and present whereabouts
unknown. Sold Brussels,
Galerie Royale, 17
December 1923, lot 51.
Photograph, London,
Witt Library, Courtauld
Institute of Art.

What lay behind Manet's rejection of the conventions of genre paint-
ing? For Castagnary in 1869, it revealed Manet's "feeling for the colored touch
[*tache colorante*]"; Paul Mantz, the same year, claimed that his concern was sim-
ply with "a combination of colors."[37] In 1868, Mantz, reviewing Manet's *Woman
with a Parrot* (New York, Metropolitan Museum of Art), saw the "symphonic
dialogue" between the pinks of the woman's dress and flesh as evidence of his
"indifference" and "dilettantism," his refusal to be moved and impassioned by

the life around him.[38] In 1868 Théophile Thoré saw Manet's preoccupation with "the *tache* of color" as evidence of "a pantheism that places no higher value on a head than a slipper."[39]

It was Manet's technique that demanded attention, both for its breadth and seeming neglect of modeling and detail and for its concern with the distinctive effects of the colored touch on the canvas. What link should be seen between this emphasis on artistic qualities and the wider question of social and moral attitudes that Mantz's and Thoré's comments raise?

The answer lies in the question of legibility itself and the debates about it in the late Second Empire. The conventions of fine art painting presented a world whose terms of reference were unambiguous: compositions should revolve around the key figures, and social status and emotional feeling should be clearly expressed. Yet much social debate in the 1860s focused on the ways in which the modern world could not be clearly read or understood, most immediately in the context of a woman's place in the contemporary city and the difficulty in distinguishing respectable women from "prostitutes." These debates turned on the same issues as were involved in the conventions of high art—on gesture, expression, and clothing—but their conclusions were different. In comparison with the comforting world of art, where everyone knew their place, modern social life presented a constant threat to legibility and hence potentially to social order.

Critics' disquiet at Manet's images of contemporary urban life raised such questions of definition and classification. The viewer could not tell what the figures in *The Balcony* were doing, gazing out onto the insecure public space of the street.[40] How did such social uncertainty relate to the artistic claims of Manet's pictures? Did this "artistic" sphere locate them apart from questions of politics, or did this very notion of the "artistic" represent a political position?

Manet's viewpoint belonged to a particular sector of Parisian artistic culture that cultivated a distance from dominant social and political values and yet set itself up as an anatomist of contemporary society. It was this detachment that opponents characterized as "indifference." Among the theorists of this position were the writers of Manet's immediate circle, notably the poet Charles Baudelaire, author of "The Painter of Modern Life."[41] In part their stance developed from a rejection of the stereotypes and hierarchies that underpinned

current social norms, but it was also crucially bound up with the question of censorship. An assumed and ironic distance was a cogent, but less tangible, mode of opposition than overt confrontation.[42]

In paintings like *The Balcony*, Manet challenged the seeming anecdotal transparency of the Stevens/Toulmouche mode by the inexpressiveness of his figures' poses and gestures. Another associate of Manet's, Edgar Degas, briefly explored a rather different way of subverting legible narrative during these same years. In pictures such as *Sulking* (New York, Metropolitan Museum of Art) and *Interior* [FIGURE 21], the figure groupings and attributes offer the viewer a wide range of potentially legible clues to the story, but in neither picture can a secure reading be reached. Particularly in *Interior*, the accumulation of details and signs seems expressly designed to thwart any coherent narrative. The woman has been

Figure 21

Edgar Degas (French, 1834–1917). *Interior*, circa 1868–69. Oil on canvas, 81.3 × 114.3 cm (32 × 45 in.). Philadelphia Museum of Art, The Henry P. McIlhenny Collection in Memory of Frances P. McIlhenny, 1986-26-10.

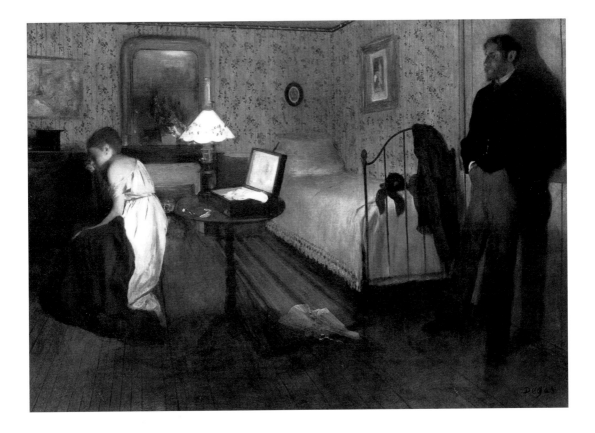

sewing at the table, but her corset is carelessly cast on the floor; the man stands with his back to the door, but a top hat appears in the far left background; they seem to be a couple, but there is only a single bed. Degas would have known well the conventions by which such genre paintings were habitually read—the illegibility of *Interior* can only have been deliberate.[43]

Where should *La Promenade* be placed in relation to these paintings and these debates? In comparison with Manet's and Degas's paintings, the poses and gestures in Renoir's canvas are expressive and legible and the interchange between the figures is intelligible. Overall it is closer to conventional, fashionable genre painting. However, in three respects *La Promenade* marks itself out as quite different from the Stevens mode and asserts its allegiance to the examples of Courbet and Manet: in the setting in which the figures are placed, in the presence of a male figure in a context such as this, and in its technique. We shall now explore each of these in turn.

THE SETTING OF *LA PROMENADE*

At first sight, there is little to say about the setting of *La Promenade*, because it is so unspecific. Nothing more is indicated than a path through dense woods. However, for the nineteenth-century viewer, the combination of setting and figures would have raised a range of issues that are central to the historical interpretation of the picture.

The forest was a potent image in the social and artistic mythology of nineteenth-century France. Both in the writings of travelers and in the many paintings of woodland interiors that appeared every year on the Salon walls, the forest was presented as a refuge from the city, a place for solitary repose and contemplation. In paintings of the Forest of Fontainebleau (the site most favored by landscapists) and of other woods within reach of Paris, the scene is generally shown as deserted or as peopled by a few, small peasant figures, treated as an integral part of the remote rural scenario.

The reality was rather different. While the landscapist Théodore Rousseau was representing the Forest of Fontainebleau as a secluded refuge [FIGURE 22], he was also actively opposing the efforts of Charles-François Denecourt to develop the area, now within easy reach of Paris by train, as a tourist spectacle.[44] This "new" forest, which Rousseau repudiated, was the subject of Monet's vast, abortive *Déjeuner sur l'herbe* of 1865–66 (fragments in Paris, Musée d'Orsay). In *Bazille and Camille (Study for "Déjeuner sur l'herbe")* [FIGURE 23], Monet depicted a man and a woman alone in a forest glade, framed by foliage in a way comparable to *La Promenade*.

In other ways, however, *La Promenade* is very unlike Monet's canvas. Renoir's setting is an enclosed, secluded space surrounded by dense bushes, rather than an open glade in a forest, and the figures suggest an active, amorous interplay, quite unlike the cool inexpressiveness of Monet's couple. The combination of setting and figures in Renoir's canvas is likely to have invited a rather different chain of associations: with the landscapes of the banks and islands of the Seine near Paris, and specifically with the image of the *canotier*.

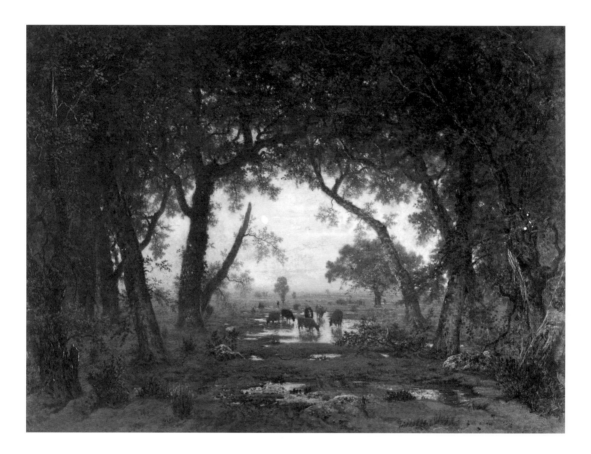

Figure 22
Théodore Rousseau
(French, 1812–1867).
*The Forest of Fontaine-
bleau, Morning*, circa
1850. Oil on canvas,
97 × 132 cm (38⅛ ×
52 in.). London, Wallace
Collection, P283.
Reproduced by permis-
sion of the Trustees of
the Wallace Collection.

Figure 23
Claude Monet. *Bazille
and Camille (Study for
"Déjeuner sur l'herbe")*,
1865. Oil on canvas,
93 × 68.9 cm (36⅝ ×
27⅛ in.). Washington,
National Gallery of Art,
Ailsa Mellon Bruce
Collection, 1970.17.41.
© 1997 Board of
Trustees, National
Gallery of Art,
Washington.

From the 1840s onward the *canotier* was a familiar figure in the mythology of Parisian life and leisure. During the week a modest worker in a shop or office, on Sundays he was transformed into the intrepid explorer of the Seine, accompanied, according to the mythology, by his "siren."[45] One writer was careful to distinguish between the serious *canotiers*, who rowed for prizes, and the many who were there purely for pleasure, who rowed energetically only

> in order to reach more quickly a quiet spot where the wine is cool . . . the trees are green and the bathing women can find a sandy bottom in the river and some shade. . . . [These *canotiers*] bring with them *canotières*, nimble, spruce, laughing, tireless, who are never worried about the morrow, provided one takes them out for an excursion, feeds them well, and appears to find them pretty.

Such excursions with "*une camarade*" rarely required much; their destination, it is made clear, was usually one of the islands in the river.[46]

In these years, Asnières, on the Seine just to the west of Paris, was the most famous site for *canotage*, but the more wooded Seine valley, a little further west around Bougival and Chatou—about ten miles west of the center of the city—was also celebrated as a site for boating and other entertainments. La Grenouillère, on the Île de Croissy in the river facing Bougival, was the most favored of the entertainment stations on the river. It offered a restaurant, bathing facilities, and a rental place for boats.

At the Salon of 1870 the expatriate German painter Ferdinand Heilbuth exhibited a view of La Grenouillère with the title *By the Waterside* [FIGURE 24]. Reviewing this picture, Zacharie Astruc evoked the place: "La Grenouillère has attracted a great deal of attention. Oh, delightful home of diving, of greenery, of *canotiers*, of free young women, of journalists lying in wait for the latest cancan, you deserve to inspire some of our likable colorists. Monet has long wanted to tackle this subject."[47] Berthe Morisot's mother succinctly described its reputation around 1868: "It is said to be a very rustic little place used for rendezvous by a very frivolous society, and that if a man goes there alone, he returns in company of at least one other person."[48]

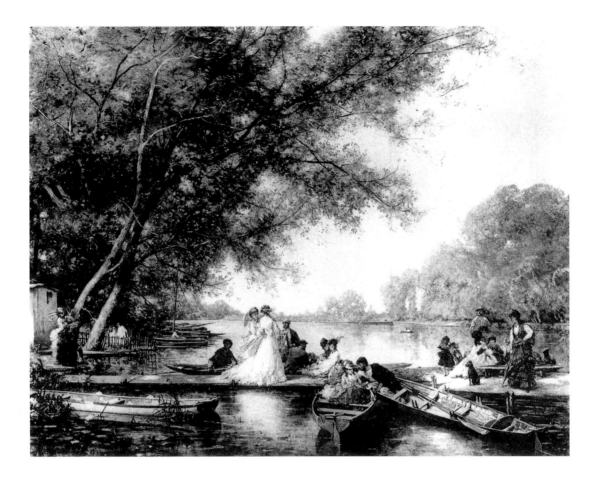

This area was a central focus in a wider network of debates about city and country. In one sense these debates had a geographical focus: where did Paris end and the country begin? How far did one now have to go to reach the "real" countryside? Even more centrally, these areas were now the arenas for a set of competing representations. What are on the surface a set of questions about the "facts" of suburban expansion are also, and more fundamentally, expressions of competing interest groups. Their battle was over what might be called symbolic territory.

In 1867 Victorien Sardou wrote of this frontier as if it could be defined in topographical terms. He described the contrast between Louveciennes, a

Figure 24
Ferdinand Heilbuth
(German, active France,
1826–1889). *By the
Waterside*, circa
1869–70. Oil on canvas,
113 × 147 cm (44½ ×
57⅞ in.). Present where-
abouts unknown; sold
Paris, Hôtel Drouot,
7 June 1911, lot 20.
Photograph, London, Witt
Library, Courtauld
Institute of Art.

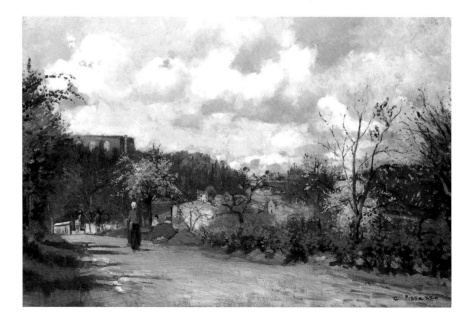

village in the hills behind Bougival, and Chatou, on the Seine itself a little nearer
Paris: "[Louveciennes] is the real village! Chatou is far away; and those little
white flurries which the wind stirs up round you on the road, they are not rice
powder . . . they are real dust."[49] This seems to be a clear, unequivocal demarca-
tion between suburb and "real" country, but two paintings act as a salutary warn-
ing. In Pissarro's *View from Louveciennes* [FIGURE 25], probably painted in the
spring of 1869, the place is presented as a rural village, with simple peasants, but
in Renoir's view of the same site [FIGURE 26], probably painted in the summer of
1870 (the same time as *La Promenade*), the village space has been appropriated
by a family of fashionably dressed Parisian day-trippers. Because of the choice of
figures, these two canvases are pictures of different genres, but the difference
between them is an expression of a far wider set of debates about the relationship
between city and country and between notions of "nature" and artifice.

Renoir was living with his mother at Louveciennes in 1870 when he
created *La Promenade*. Late in the summer of 1869 he and Monet had painted a
number of pictures at La Grenouillère [FIGURES 27, 28, for example], viewing
the place from much the same angle as Heilbuth's *By the Waterside* [FIGURE 24].
In a letter to Frédéric Bazille, Monet described his own versions of the place as

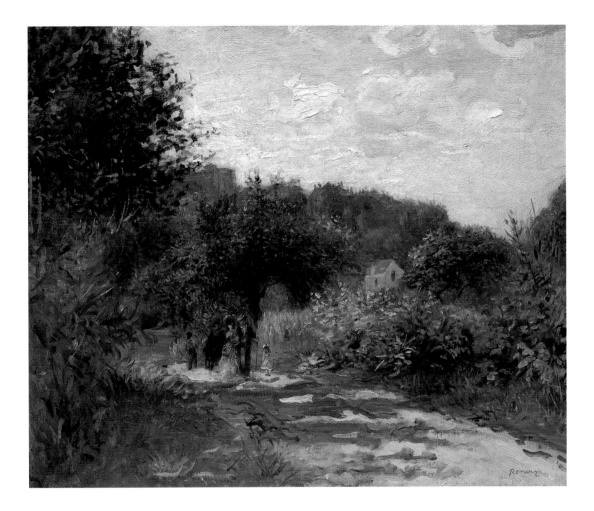

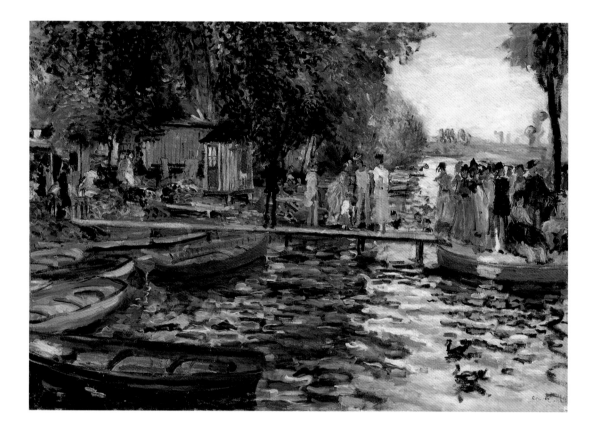

Figure 27
Pierre-Auguste Renoir.
La Grenouillère, 1869.
Oil on canvas, 65 × 92
cm (25½ × 36¼ in.).
Winterthur, Switzerland,
Oskar Reinhart Collection
"Am Römerholz."

Figure 29
François Compte-Calix
(French, 1813–1880). *A
Corner of a Garden*, circa
1868. Oil on canvas, size
and present whereabouts
unknown. Reproduced
from a photograph pub-
lished by Goupil and Co.,
circa 1869. London, Witt
Library, Courtauld Institute
of Art.

"bad sketches" but declared that both he and Renoir wanted to make a sig-
nificant picture of the subject.[50] The figures in Renoir's La Grenouillère paint-
ings are very similar in type to those in *La Promenade*.

Certainly there is nothing in *La Promenade* that allows its site to be
pinpointed; there is no sign, even, that the scene is near the river. All that is
clear is that the rough, uncultivated terrain—the uneven, irregular path and the
dense foliage—is not that of the enclosed, protected space of a park or garden.
Indeed, the contrast between gardens and open countryside was fundamental in
the contemporary imagery of courtship. This can be clearly seen from the con-
trast between *La Promenade* and *The Engaged Couple* [FIGURE 14], with its gar-
den setting, and between the demureness of François Compte-Calix's *A Corner
of a Garden* [FIGURE 29], of the late 1860s, and the suggestiveness of his *A Little
Path That Leads Far* [FIGURE 30], shown at the 1875 Salon.

44

La Promenade offers none of the topographical points of reference that have been a major focus of research on the art of the Impressionists in recent years.[51] However, the imagery of a young man and woman in informal urban clothes, particularly the male figure's ribboned hat (a type of headgear associated with the *canotier*), link it with that of pleasure seekers in the Seine valley to the west of Paris. Reviewing *Lise* [FIGURE 12] at the Salon of 1868, Zacharie Astruc had no doubt that this female figure standing in the woods should be seen as a lower-class *parisienne* on an outing from the city:

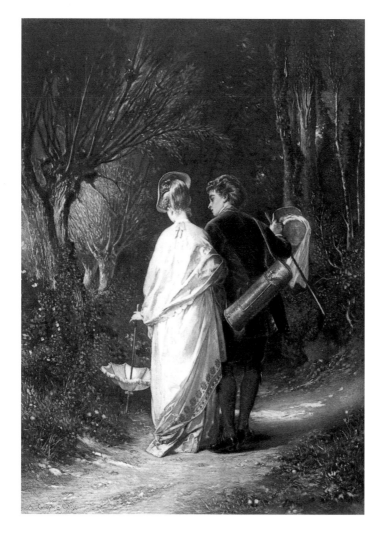

Figure 30
François Compte-Calix.
A Little Path That Leads Far, circa 1875. Oil on canvas, size and present whereabouts unknown. Reproduced from a photograph published in Goupil and Co., *Salon de 1875*. London, Witt Library, Courtauld Institute of Art.

She is the likable Parisian girl in the Bois . . . seeking the shade not for its coolness and solitude, but for the entertainments there: the ball, the pleasure garden, the fashionable restaurant, the freak tree converted into a dining room. . . . [Renoir's] heroine has nothing rustic about her except her features. She is a brunette, ruddy complexioned, plump, vigorous and healthy, and not lacking in spirit, I imagine. Her eyes express clearly her native mischievousness and her incisive working-class [*populaire*] perceptiveness.[52]

The imagery of amorous excursions from Paris had a significant artistic ancestry, and even when no precise site was shown, critics were often ready to identify such images with particular places and to invoke their reputation when interpreting the pictures. Courbet's *Young Women of the Banks of the Seine, Summer* [FIGURE 8], Manet's *Déjeuner sur l'herbe* (Paris, Musée d'Orsay), and Renoir's *Bather with a Griffon* [FIGURE 7] had made explicit the theme of the secluded island in the river, reached by rowboat, although without identifiable topographical details. Courbet's canvas, in particular, was at once associated with the islands in the Seine. *Bather with a Griffon*, shown at the 1870 Salon, was presumably the ambitious canvas that emerged from Renoir's work at La Grenouillère in the autumn of 1869, a fascinating indication of the difference he perceived between a landscape study and a significant exhibition picture. Renoir had in 1866 painted a canvas, *Outing in a Rowboat* [FIGURE 31], which made explicit the link between such outings and the flirtatious excursion into the woods that forms the subject of *La Promenade*. Such images picked up on the traditional imagery of the "isle of love," with its artistic reminiscences of Watteau's *Embarcation for the Isle of Cythera* (versions in Paris, Musée du Louvre, and Berlin, Staatliche Museen); these stereotypes were also alluded to in contemporary literature.[53]

The particular resonance of La Grenouillère and the Île de Croissy emerges from a review by Théophile Gautier *fils* of James Tissot's *The Secret (Confidence)* [FIGURE 32] at the 1867 Salon. Although the picture carries no clear indication of the site shown (beyond the presence of a riverbank), Gautier confidently located the setting in his imaginative re-creation of the scene:

46

Figure 31
Pierre-Auguste Renoir. *Outing in a Rowboat*, 1866. Oil on canvas, 67.9 × 90.8 cm (26¾ × 35¾ in.). Private collection. Christie's Images, New York.

Definitively renouncing his pastiches of Leys, M. James Tissot enters . . . the heart of modern life: it is doubtless on the banks of the Île de Croissy, facing Bougival, that the *Confidence* is taking place whose image he shows us without clearly revealing the secret. The branches of the willows are discreetly entangled around them . . . , no breeze disturbs the water; everything is silent, and these two young women, leaning toward each other, may, without fear of being surprised, impart . . . the confidence that has perhaps been long hidden deep in the heart.[54]

Gautier's insistence on the relationship between the subject and the enfolding landscape is particularly relevant to the image of a different sort of privacy in *La Promenade*.

47

It was in contexts such as these that the outskirts of Paris came to be seen in some sense as epitomizing the moral problems of the capital itself, and hence of the nation at large. The frivolous pastimes and sexual encounters that recur constantly in descriptions of the city's periphery were a marker of a larger anxiety—the loss of a fundamental set of values. These concerns emerge clearly from the 1877 preface to Adolphe Joanne's oft-reprinted guide to the environs of Paris. Joanne urged Parisians to explore the surroundings of the city—the landscape and its climate, the castles, churches, abbeys, and palaces—both for their beauties and for their eloquent historical associations. At the same time he lamented how little Parisians knew of these:

> Parisians do not know how to go on excursions [*se promener*] in a profitable way. If they escape for a few hours from the appalling prisons of stone or plaster in which they purchase at too great expense the right to be shut up without air, space, or light, they rush in bands to particular places to which their naïve curiosity is attracted by shameful publicity; they crowd together promiscuously in public establishments that are even more unhealthy and unappealing than their homes, in order to seek out trivial diversions that have nothing to do with the countryside and which they could have procured more cheaply within the great city.[55]

La Promenade presents the image of one of these excursions; we must now look at the figures themselves in order to see what the picture reveals about their promenade and its goal.

Figure 32
James Tissot (French, 1836–1902). *The Secret (Confidence)*, circa 1867. Oil on canvas, 86.5 × 72 cm (34 × 28⅜ in.). Tokyo, Ishizuka Collection.

THE FIGURE SUBJECT IN *LA PROMENADE*

Figure groups in paintings that appear to show everyday images of contemporary life need to be viewed from two perspectives, one social, the other artistic. The figures can be studied in relation to the social practices they display and also in their artistic context, as images presented to viewers as fine art, with all the value-laden associations that this implies. Here, *La Promenade* presents an immediate paradox. The imagery of relaxed entertainments and excursions, and of flirtations between men and women, was widespread in Paris in the 1860s, but only in the lower-status media of illustration, graphic journalism, and printmaking. In the world of fine art painting, to which Renoir's canvas unequivocally belonged, such subjects were most unusual.

Male figures were only very rarely included in fashionable genre paintings of scenes from modern life. Often, in interior views of the Stevens/Toulmouche mode, the idea of a man is hinted at—by a letter a woman is reading, by some keepsake, or by the evident direction of her thoughts [see FIGURES 5, 17, 20]—but it was most unusual for a male to put in an appearance in a woman's space. In two examples where a man does appear, the distinction between masculine and feminine spheres is stressed. In Eugène Feyen's *The Honeymoon* [FIGURE 33], shown at the 1869 Salon, a man working at his desk turns aside briefly to kiss his wife, who sits behind him dutifully sewing, confined to passivity and domesticity even at the outset of their marriage. Toulmouche's semicomic *The First Visit* [FIGURE 34], from the 1865 Salon, plays on the man's evident awkwardness as he, and his remarkable top hat, penetrate a female domestic space.

Why were male figures normally excluded from such paintings? The fact that they so regularly appeared with female figures in illustrations in magazines such as *La Vie parisienne* shows that it was not only a question of moral propriety but also in part a matter of artistic decorum. What was perfectly acceptable in illustration did not belong in the sphere of fine art. For Théodore Duret in 1870, the answer was simple: male costume was too drab and ugly to

Figure 33
Eugène Feyen (French, 1815–1908). *The Honeymoon*, circa 1869. Oil on canvas, size and present whereabouts unknown. Reproduced from a photograph published by Goupil and Co., circa 1869. London, Witt Library, Courtauld Institute of Art.

Figure 34
Auguste Toulmouche. *The First Visit*, circa 1865. Oil on canvas, size and present whereabouts unknown. Reproduced from a photograph published in P. G. Hamerton, *Contemporary French Painters* (London, 1869).

merit inclusion in paintings, whose prime concern was to show off the glamour and shimmer of women's clothing.[56]

A further reason may lie in the question of individuality and individualization. Critics readily recognized that the female figures that appeared in paintings were types that represented stereotypical notions of femininity through their appearance, gestures, and behavior. By contrast, there was no language—either visual or cultural—for typecasting contemporary bourgeois male figures in this way. Jules Castagnary explored these issues in his review of the Salon of 1857. He described a sliding scale of individuality in the countryside, leading from the plant to the animal to the peasant figure (peasants were considered part of the land in which they lived and worked). Later in the review he extended this notion to the urban world, contrasting the unformed child and the superficial, external image that women cultivated with the fully-fledged individuality found only in the adult bourgeois male. Only one art form—portraiture—was able to express this true individuality.[57]

The position of the artist was that of the modern, urban bourgeois male, and the notion of artistic creativity depended on a notion of individuality, the uniqueness of the individual experience. It was this, perhaps, that made it impossible for fine art to evolve a credible set of stereotypes for the urban male figure. By contrast, the worlds of graphic illustration or satirical caricature could, as lesser genres, distance themselves from the bourgeois male and view him, like his female counterpart, as part of the tableau of *la vie parisienne*.

This is not, though, to exclude the issue of moral propriety. The Salon walls operated a vivid double standard, with mythological debauches such as Alexandre Cabanel's *Nymph Abducted by a Faun* of 1860 [FIGURE 39] being viewed by most commentators as acceptable, while Manet's *Déjeuner sur l'herbe* (Paris, Musée d'Orsay), excluded from the Salon but shown in the Salon des Refusés in 1863, remained a cause célèbre, with its clothed male figures alongside a naked woman. Even when there was no male presence, modern-life female nudes such as the *Bather with a Griffon* [FIGURE 7] were also controversial.[58]

Likewise, images of courtship were acceptable when presented in historical or mythological guise. Heilbuth's *Spring* [FIGURE 35], shown at the 1869 Salon, aroused no anxiety, because its figures were dressed in Venetian

Figure 35
Ferdinand Heilbuth.
Spring, circa 1869. Oil
on canvas, size and
present whereabouts
unknown. Sold Paris,
Sedelmeyer sale, 1907.
Photograph, London,
Witt Library, Courtauld
Institute of Art.

Renaissance costume, although the background landscape clearly resembled the Seine valley with its islands. At a more frivolous level, the Directoire costume of circa 1800 made a picture such as Étienne Berne-Bellecour's *A Lovers' Nest* [FIGURE 36] acceptable. Tissot in these years was making a speciality of risqué subjects in Directoire costume; both of his 1870 Salon exhibits, *A Foursome* (*Partie carré*) and *Young Woman in a Boat*, presented Directoire-costumed figures in Seine riverside settings.[59]

In order to focus more closely on the figures in *La Promenade*, the question of the picture's title is pertinent. As we have seen, it is not known what Renoir originally called his painting, although it is possible that *La Promenade*

was the title from the very beginning. In later years Renoir was scornful of sentimental titles given his pictures in order to help them sell. Told of a canvas put up for auction as *La Pensée*, he brusquely retorted: "My models do not think."[60] Late in his life he said, perhaps disingenuously: "Why have they given names to my pictures which never represent the reason I painted such and such a subject? My joy consists in painting, and it has never been in my mind to paint a preconceived subject."[61] Presumably titles such as *La Première Sortie* (London, National Gallery) were not the artist's.

However, the title *La Promenade* is more neutral in its associations, and Renoir did exhibit a picture, now known as *Mother and Children*, with the title *La Promenade* at the second Impressionist group exhibition in 1876 [FIGURE 37]. This, however, was a picture of a rather different type: a large canvas of a young woman guiding two fashionably dressed girls through a public park. The idea of the "promenade" was not confined to such public spaces, however, as Raimundo de Madrazo's *After the Promenade* [FIGURE 38] shows. In this work from the late 1860s, a young woman has returned home; with her dress half-removed, she ponders over a memento, while the painting on the background wall hints at the location of her recent promenade—a riverside landscape showing a scene very like the banks of the Seine near Bougival and La Grenouillère.

This extended analysis of the context of *La Promenade* suggests the range of associations that the picture and its imagery would have evoked for its first viewers. However, the poses and gestures of Renoir's figures themselves, in their secluded woodland setting, seem unambiguous. Indeed, there is an exaggerated and almost caricatural quality to the man's gesture that is closer to the visual language of the illustrative prints found in magazines such as *La Vie parisienne* than it is to the more restrained gestures characteristic of fine art genre painting. There is no reason to suppose that a nineteenth-century viewer would have been in any doubt about the interplay between Renoir's figures—between the man's encouragement and the woman's momentary hesitation—or about the destination that the man has in mind. Images of lovemaking in secluded woodland settings were common in nineteenth-century imagery, ranging from the mildly suggestive, like Compte-Calix's *A Little Path That Leads Far* [FIGURE 30], to the overtly pornographic.[62]

Figure 36
Étienne Berne-Bellecour (French, 1838–1910). *A Lovers' Nest*, 1870. Oil on canvas, size and present whereabouts unknown. Reproduced from a photograph published by Goupil and Co., circa 1871. London, Witt Library, Courtauld Institute of Art.

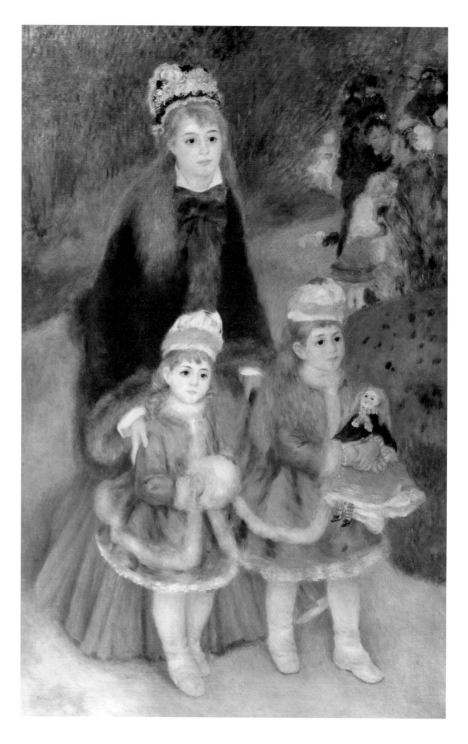

Figure 37
Pierre-Auguste Renoir.
Mother and Children [*La Promenade*], circa 1875.
Oil on canvas, 168 × 104.1 cm (66⅛ × 41 in.). New York, The Frick Collection.

Figure 38

Raimundo de Madrazo (Spanish, 1841–1920). *After the Promenade*, circa 1868. Oil on canvas, size and present whereabouts unknown. Reproduced from a photograph published by Goupil and Co., circa 1868. London, Witt Library, Courtauld Institute of Art.

Renoir's own *Lise* [FIGURE 12] tackles much the same theme, with the crucial difference being that the male presence is awaited, not seen. The pose and gesture of the female figure can best be understood as one of expectation, while the tree beside which she stands in the wood bears carved initials, a standard emblem of a lovers' trysting place.[63] *La Promenade* can readily be seen as the next stage in a very similar narrative.

The effect of the figures in *La Promenade* is heightened by the way in which the composition is arranged and the lighting orchestrated. While the woman is framed by foliage and set off against the dark thicket beyond her, the man is wedged into the upper right corner of the canvas, his head tight beneath its top margin. The lighting plays a crucial role in the presentation of the scene

but blatantly rejects academic precept. Alphonse de Calonne outlined the conventional view in 1853:

> In a painting nothing should be left to chance; everything should be carefully calculated and worked out. If the painter focuses the light on a particular point in his picture, this is to give greater significance to that point. In a landscape or an interior, this point may be chosen merely for its material effect; the principal subject in a picture of this sort is always the interior or the landscape itself. However, in a composition where groups of figures play a part in the action . . . , the effects of light must be calculated so as to give greater significance to the principal characters; above all, one must avoid attracting attention to secondary objects and producing a confused and disjointed effect.[64]

In *La Promenade* both figures are crucial to the action, but they are very differently treated. The woman is fully and frontally lit; she is emphatically the prime focus of the picture. Only scattered flashes of sunlight illuminate the man—on his trousers and hands, his collar and hat—while the rest of his figure is seemingly absorbed into the foliage behind him. By contrast, the pathway through the woods—a "secondary object"—is largely in sunlight, providing a clear visual pointer out of the picture. This, of course, is a significant factor in the action, directing attention to the path that the man urges the woman to follow, to the prospective action of the couple.

This playful contrast between lit and shadowy figures is heightened by the shade on the man's face and the highly simplified, almost caricatural treatment of his features. There are no signs of individualization here! Immersed in the woods, he becomes a Pan-like or satyr-like figure, luring his modern nymph into his lair. Viewed in this context, *La Promenade* becomes a delightful parody of one of the most notorious genres of contemporary academic painting, exemplified by Cabanel's *Nymph Abducted by a Faun* [FIGURE 39], purchased by Napoleon III at the 1861 Salon and exhibited again at the 1867 Exposition Universelle.

As a genre painting of modern life, *La Promenade* has none of the illegibility and inscrutability of Manet's Salon genre paintings [FIGURE 19, for

Figure 39
Alexandre Cabanel
(French, 1823–1889).
Nymph Abducted by a Faun, 1860. Oil on canvas, 245 × 142 cm
(96½ × 57⅞ in.). Lille, Musée des Beaux-Arts, no. 525.

example]. It presents a recognizable world whose characters can be identified in social terms and whose actions are clearly presented. Nothing in the picture demonstrates whether the woman will follow the man where he seeks to lead her, but the scenario and the suggestion of the possibility of a secretive sexual encounter are unambiguous.

In these terms *La Promenade* is comparable to the fashionable genre paintings of the Stevens/Toulmouche type. Where it differs from them is in the social world it depicts. These are not intrigues among the haute bourgeoisie or the lavishly endowed *lorettes* of Paris. Rather, this is a more modest and less etiquette-dominated world, the semibohemian sphere of the *canotier* and his *camarade*. He can be imagined in his weekday life as a petit bourgeois, and she as one of the legendary grisettes, the good-hearted girls so common in the mythology of bohemian life in Paris who were interested in handsome young men for their charm, not their money.[65]

The informality of the social life that the picture presents is complemented by the informality of its technique. This must now be examined before Renoir's position in the Parisian art world in 1870 can be evaluated.

The Technique of *La Promenade*

L *a Promenade* occupies an intermediate position within Renoir's oeuvre around 1870. It is far more fluently and informally painted than a contemporary Salon picture such as *Bather with a Griffon* [FIGURE 7], but in comparison to rapidly notated sketches such as his views of La Grenouillère [FIGURES 27, 40, for example], it is quite elaborately finished. These contrasts clearly reflect the different status of these three types of paintings: the large Salon oil for public exhibition, the smaller but generally resolved canvas designed for sale to a private collector, and the rapid sketch that was not meant for immediate sale and display (Monet described his very comparable canvases of La Grenouillère [FIGURE 28, for instance] as *pochades*, an informal artistic term for particularly rapid sketches).[66] A similar contrast can be found among Renoir's landscapes from around 1870. The comparative finesse and elaboration of *A Road in Louveciennes* [FIGURE 26]—very comparable in touch to *La Promenade*—is quite unlike the improvisatory breadth of *Barges on the Seine* [FIGURE 41]. Likewise, Monet's *The Seine at Bougival* [FIGURE 42], sold to the dealer Martin, can be contrasted with his La Grenouillère *pochades*.

Viewed in a wider context, though, Renoir's technique in *La Promenade* engages with many key issues of the period: the relationship between tonal values and color, the role of drawing and modeling in the suggestion of form, and the relationship between surface elaboration and perspectival space.

La Promenade utterly repudiates the conventional notion of drawing as a means of demarcating between forms by a hard, clear-cut linear boundary. Here, Renoir evidently followed Delacroix's dictum that there were no lines in nature, in contrast to Ingres's insistence that, in art, line should always play the primary role. The contrast to the harsh contouring of an artist such as Toulmouche [FIGURES 5, 34] is immediately apparent. Toulmouche, like Renoir, had studied under Charles Gleyre, but, unlike Renoir, he remained faithful to his academic training.

The overall play of varied color in *La Promenade* further emphasizes Renoir's allegiance to Delacroix's example. However, the figures are conveyed by a combination of means that show him simultaneously exploring two distinct modes of suggesting three-dimensional form. The woman's dress is primarily modeled in tonal terms; its folds and crinkles are suggested by soft grays with scarcely a trace of color set off against the whites of material where it catches the sun. At the same time, clearer, light blue hues are used down the right margin of the dress and on the right side of the sleeve, introducing an alternative mode of modeling, by color contrasts, with the cool blues set off against the soft pinks that are seen at some points in the sunlit areas of the dress down the sleeve and around the neck. These pinks do not merely serve to heighten the effect of the blues; they can be seen as suggesting the woman's flesh, sensed through the material.

The man's trousers are more boldly handled. Blue is used more extensively in the shadowed zones, and the lit areas include traces of both pink

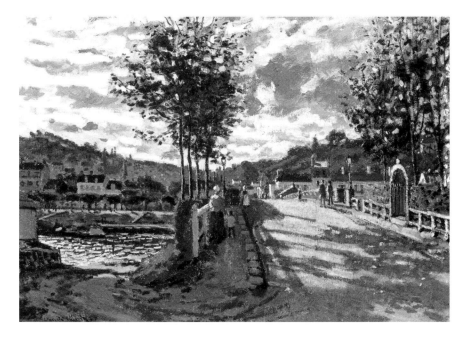

Figure 41
Pierre-Auguste Renoir.
Barges on the Seine,
circa 1870. Oil on can-
vas, 47 × 64 cm (18½ ×
25¼ in.). Paris, Musée
d'Orsay, RF 3667.

Figure 42
Claude Monet. *The Seine
at Bougival*, 1869. Oil on
canvas, 65.4 × 92.4 cm
(25¾ × 36⅜ in.).
Manchester, N.H., The
Currier Gallery of Art,
Currier Funds, 1949.1.

and yellow. The highlights on the trousers are freely scattered; the light-hued accents suggest the play of sunlight through foliage. They are applied, however, with a breadth and fluency that prevents the touches from being read in any literal sense as reflecting the play of light and shade. Beyond this, the particularly emphatic highlight near the man's groin may be seen as a hint of the sexual dimension of the scene.

Throughout the picture, flecks and dashes of contrasting tone and color animate the surface. At times, as on the path and in the foliage up the right margin, the effect is primarily achieved by shifts of color. Elsewhere, though, sharp contrasts of tone dominate. The brushwork, too, is variegated throughout. The foliage, earth, and clothing are differentiated from each other by a highly flexible painterly shorthand that evokes a sense of their textures without ever hinting at an illusionistic transparency of surface. The activity of the brush on the canvas always remains instantly visible.

The effects of this type of painting, in contrast to more traditional notions of modeling, were well analyzed in an 1870 Salon review by the critic Philippe Burty, whom Renoir knew, in discussing *Summer Scene* [FIGURE 43], an ambitious canvas of male bathers by Renoir's close friend Frédéric Bazille:

> It is clear that this is a deviation from realism, and that this new school, whilst wanting to remain truthful to general appearances, seeks to be more artistic through a more delicate choice of colors, through the absence of bituminous shadows, through a more faithful investigation of light as it falls from the sky in the green countryside. But figures or objects do not present themselves only in terms of colored *taches* and their luminous planes. They exist also in terms of what lies beneath. Even if classic teaching methods have for a long time abused this abstract line, which is supposed to circumscribe form and is called the contour, one should still not fall into the opposite excess and limit oneself to juxtaposing zones of light and dark, floating like white or dark clouds on a blue sky.[67]

Although *La Promenade* rejects traditional modeling, the play of tone and color and the variety of touch and texture create a sense of form and space. The brushwork gives no sense of flatness. The surface effects of the

Figure 43
Frédéric Bazille. *Summer Scene*, 1869. Oil on canvas, 160 × 160.7 cm (63 × 63¼ in.). Cambridge, Mass., Fogg Art Museum, Harvard University Art Museums, Gift of Mr. and Mrs. F. Meynier de Salinelles, 1937.78.

painting are quite unlike those in Manet's contemporary work [such as FIGURE 19]; his *taches* of color are more schematic and stylized, creating an evenness of weighting and emphasis that can more readily be seen in two-dimensional terms. Renoir's brushstrokes can be read as a more direct response to his *sensations*—as a shorthand for his immediate visual experiences of the forms and textures in front of him.

Despite the constant variegation, the overall effect of *La Promenade* is one of unity. The composition is carefully framed. The tree trunk at bottom right and the twigs silhouetted against the woman's dress act as *repoussoirs* in the foreground, framing the scene and leading the eye into it, while the dark foliage behind her closes in the left background. Only the path on the right

opens out the space to what lies beyond. For all its variety, the constant animation of the brushwork lends a further sense of coherence to the whole, and similar colors recur in many parts of the canvas. Most significantly, a sequence of pinks and reds across the picture, set off against the surrounding cool greens and blues, operates in both aesthetic and thematic terms. It leads from the woman's face and hat through the joined hands (the reds are quite intense here) to the man's face and the remarkable red ribbon on his hat and finally to his left hand, pointing to where he wishes her to go.

Throughout the canvas, color and touch together create a complex weave. The effect is never repetitive or systematic, but retains a sense of freshness and informality, of pictorial solutions worked out as the picture evolved. This painterly virtuosity recognized no rules and saw no limits to its capacity to improvise. Renoir's touch does not have the measured density of Manet's or Monet's, the capacity to create the most vivid effects and contrasts with a few incisive strokes. However, the technique of *La Promenade* is vivid testimony to

the belief that an art devoted to the theme of modern leisure demanded an impromptu quality that somehow corresponded to the way of life it evoked.

Viewed in a wider context, the assertive visibility of the brushwork in *La Promenade* would have marked it as the type of painting that appealed to a truly artistic viewership, in contrast to the popular appeal of genre paintings such as Toulmouche's. Two critics made this point in reviewing Renoir's *Lise* [FIGURE 12] at the 1868 Salon. Zacharie Astruc commented that it stood out from "commercial works" and won the approval of fellow artists and *connaisseurs*; Jules Castagnary noted its success among *connaisseurs*, stressing that this appeal derived from the boldness of its technique, especially from the halftones used to model the figure.[68]

These responses show how far Renoir's art was analyzed within the same terms of reference as Manet's in these years. As previously mentioned, Manet's concern for the *tache* of color marked his work out as "artistic"; in 1870 three critics who were close associates of Manet's—Astruc, Burty, and Duranty—all reiterated this connection between his technique and his audience in reviewing his work at the Salon, emphasizing the failure of the wider public to understand his art.[69]

Painting by *taches* served as a marker of the artist's distinctive, personal vision and of his efforts to translate into paint his *sensations* of the world around him.[70] This aesthetic became the basis of the Impressionists' art in the mid-1870s, the years of their first group exhibitions.[71] In these terms, the technique of *La Promenade* makes it one of the first true Impressionist pictures. We must now explore its style and subject together in order to reveal Renoir's position within debates about modern art in Paris in 1870.

Figure 44
Henri Fantin-Latour
(French, 1836–1904). *A Studio in the Batignolles*, 1870. Oil on canvas, 204 × 273.5 cm (80⅜ × 107⅝ in.). Paris, Musée d'Orsay, RF 729.

RENOIR'S POSITION IN 1870

In addition to having two pictures on the exhibition walls, Renoir played another starring role at the Salon of 1870. In Henri Fantin-Latour's group portrait *A Studio in the Batignolles* [FIGURE 44], showing Manet at work surrounded by his friends and supporters, Renoir appears standing in the center background, his head precisely framed by the secular halo of a gilt picture frame. Alone of the figures in the oil, he wears a hat, and his lean features gaze intently at the canvas on which Manet is working. Given the solemn tone of Fantin-Latour's painting, it is not surprising that Bertall caricatured it in 1870 as *"Jesus Painting among His Disciples" or "The Divine School of Manet," religious picture by Fantin-Latour.*[72]

Renoir's presence in Fantin-Latour's picture identified him clearly as one of Manet's admirers and followers. This loosely structured grouping had been recognized by a number of critics at the Salons of the two previous years; in 1869 Duranty had named the artists the "School of the Batignolles," taking the name from the area in northwestern Paris where Manet had his studio and where the Café Guerbois—a regular meeting place for the group—was located.[73]

Manet was, of course, the most celebrated member of the group; by 1870 even the critics who most disliked his work felt forced to discuss it at length. Of the other painters in Fantin-Latour's canvas, Monet was perhaps the most notorious—most of his pictures had been rejected by the Salon jury over the past four years—yet he is placed at the far right margin of the composition. It is not known why Fantin-Latour gave Renoir so prominent a role, but his presence here enshrines his position in the "School of the Batignolles."

Viewed in broader terms, Renoir's position and career in 1870 can be understood in a number of different ways. His work highlighted his links with Courbet and Manet, and Fantin-Latour's picture placed him firmly in Manet's camp. Renoir, however, did not adopt the overtly confrontational strategies that, in their different ways, characterized both Courbet's and Manet's art, nor did he cultivate the aggressively bohemian lifestyle that contributed to Monet's notoriety in these years.

Renoir's exhibition paintings at the 1870 Salon, notably *Bather with a Griffon* [FIGURE 7], highlighted his wish, like that of Manet, to harness old master prototypes to explicitly modern themes, but he consistently used these prototypes less provocatively than Manet. Likewise, as has been shown, pictures like *La Promenade* did not challenge the conventions of genre and narrative painting in the ways that Manet's did.

Viewed in this perspective, Renoir's paintings of these years do not readily invite a political reading, in terms of republican "indifference," comparable to Manet's. It would be mistaken to conclude from this, however, that Renoir was disengaged from current social and political issues. His paintings of the time show that he was deeply committed to an aesthetic of modernity. The hindsight of his pronouncements in his later years has left behind the picture of an artist opposed to the modern city; it was almost in passing that his son, Jean, in his memoir of his father, acknowledged that, in his youth, Renoir had approved of the modernization of Paris under Baron Haussmann in the 1850s and 1860s.[74]

As we have seen, Renoir's Grenouillère paintings and *La Promenade* engage with a crucial dimension of this modernization process—the irruption of urban recreation into the countryside around Paris. Far from the strictures of contemporary moralists, they suggest an active enjoyment, relish even, in the life of the pleasure spots on the fringes of Paris. In this context, it is perhaps no coincidence that Renoir's own social background, from the humble artisanal petite bourgeoisie, was closer than that of any of his colleagues to the background of the typical Parisian day-tripper.[75]

There is a paradox here, though. The world that Renoir was celebrating was a popular one, and his approach to it was one of positive engagement, not moral critique or humanitarian concern from a viewpoint outside that world. However, the medium he was working in—the oil painting—belonged to the realm of fine art and high culture.

Certainly the photographic reproductions of genre paintings sold by dealers such as Goupil [see, for example, FIGURES 5, 17, 18] were directed at a more popular audience than the original oils, but as critics pointed out, the execution of paintings such as these—crisply drawn and meticulously finished—could be seen as being designed for photographic reproduction. By contrast, Renoir's painterly fluency made sense only when the original work was seen.

Indeed, as previously mentioned, such handling was widely considered at the time as a marker of the distinctive temperament and personality of the true artist.

Renoir's position in these years is perhaps best characterized in terms of bohemianism. His lifestyle, as he migrated from shared studio to shared studio, followed the stereotypes of bohemian life, as did his relationship with Lise Tréhot, from what little is known of it. The surviving testimony from the 1870s about his personal habits and behavior amply confirms the image of a man resolutely refusing to conform to bourgeois social norms.[76]

Renoir's bohemianism is best characterized not by biographical details but rather through his persona, the image he projected of his work and career. Here, it is the range and combination of different elements that is significant. At the Salon he exhibited both ambitious modern-subject pictures like *Bather with a Griffon* [FIGURE 7] and "studies" like *In Summer: Study* [FIGURE 13]; his landscapes ranged from the finesse of *A Road in Louveciennes* [FIGURE 26] to the breadth—deliberate crudeness, even—of *Barges on the Seine* [FIGURE 41]; his subject matter might engage with a fantasy harem, as in *Woman of Algiers* [FIGURE 9], or with the popular imagery of magazines like *La Vie parisienne*, as in *La Promenade*. The former artisan porcelain painter even appears as a secular acolyte of the "divine" Manet in Fantin-Latour's group portrait [FIGURE 44].

The range of different social and artistic stances that Renoir adopted reveals his refusal to be typecast, in either aesthetic or social terms. Bohemianism cannot be viewed as a position outside the structures of social class, but it defined itself by its refusal to be coopted by any one social grouping. It was not working class or artisanal, nor was it bourgeois, except for the fact that many self-appointed bohemians came from bourgeois backgrounds. According to contemporary mythology, it was not explicitly political, but inevitably the bohemian was viewed as an opponent of the establishment, through the outsider position he adopted.[77]

In some ways, this stance anticipates the social and aesthetic ideals of Renoir's later years, but the Renoir of 1870 needs to be distinguished from the Sage of Cagnes after 1900, both because of his active engagement in the central issues of the contemporary art world and because of his commitment, in both his art and his life, to an explicitly modern, urban world view.

The Place of *La Promenade* in Renoir's Career

At the end of his life, Renoir told his son what he felt about subject matter in art:

> What is important is to escape from the *motif*, to avoid being literary and therefore to choose something that everyone knows—better still, to have no story at all. . . . Under Louis XV, I would have been obliged to paint subjects. What seems to me the most important thing about our movement is that we have freed painting from the subject. I can paint flowers and simply call them "flowers" without their having a story.[78]

Our exploration of *La Promenade* and the types of readings it invites has shown that it was indeed the sort of picture that might have been interpreted in terms of a "story," but at the same time, the way in which the subject was treated would have prevented the canvas from being understood purely in narrative terms.

During the 1870s Renoir gradually drained his genre scenes of specifically narrative legibility. Two paintings of couples in the woods from the mid-1870s clearly take up the theme of *La Promenade*, but the titles these now bear—*Confidences* [FIGURE 45] and *The Lovers* [FIGURE 46]—are almost certainly not Renoir's own. He did not exhibit any paintings in these years with such explicitly anecdotal titles, and inevitably they condition the way the pictures are viewed today.

In *Ball at the Moulin de la Galette* [FIGURE 47], Renoir's major tableau of modern Parisian life that was the centerpiece of the third Impressionist exhibition in 1877, the principal groupings of figures cannot readily be interpreted anecdotally. Only a few subsidiary couples in the background invite such a reading: the woman in blue turning away from the man in a top hat on the bench at back left, the over-urgent man dancing at back center, and the man to the right who leans on the tree to say something to the woman in blue with her back to him. *The Swing* [FIGURE 48], shown at the same exhibition, wholly thwarts such readings; there is no clue given to the reason for the

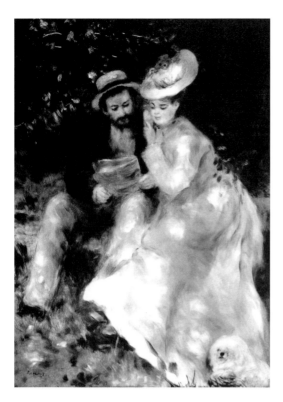

woman's gesture or to her relationship to the two men. Renoir confused the potential narrative even further by the inclusion of the child. The artist told his friend Georges Rivière that the youngster, who had been watching Renoir paint, was inserted into the picture without being aware of it.[79]

Likewise, Renoir's great image of riverside entertainments, *Luncheon of the Boating Party (Déjeuner des canotiers)* [FIGURE 49] of 1881, is particularly resistant to anecdotal readings, despite the fact that the theme of *canotiers* was inextricably linked, in popular mythology, with narratives of amorous interchange and sexual intrigue. Even the most apparently legible grouping can be understood in two quite different ways: is the woman at back right closing her ears to the blandishments of the man who has his arm around her (his hat is startlingly like that worn by the man in *La Promenade*), or is she simply adjusting her hat before leaving?

Figure 45
Pierre-Auguste Renoir. *Confidences*, 1875. Oil on canvas, 81.3 × 60.3 cm (32 × 23¾ in.). Portland, Maine, The Portland Museum of Art, The Joan Whitney Payson Collection, Gift of Joan Whitney Payson, 1991.62.

Figure 46
Pierre-Auguste Renoir. *The Lovers*, 1875. Oil on canvas, 175 × 130 cm (68⅞ × 51⅛ in.). Prague, Národní Galerie, no. O 3201.

Figure 47
Pierre-Auguste Renoir.
*Ball at the Moulin de la
Galette*, 1876. Oil on
canvas, 131 × 175 cm
(51½ × 68⅞ in.). Paris,
Musée d'Orsay, Bequest
of Gustave Caillebotte,
1894, RF 2739.

Figure 48
Pierre-Auguste Renoir.
The Swing, 1876. Oil on
canvas, 92 × 73 cm
(36¼ × 28¾ in.). Paris,
Musée d'Orsay, Bequest
of Gustave Caillebotte,
1894, RF 2738.

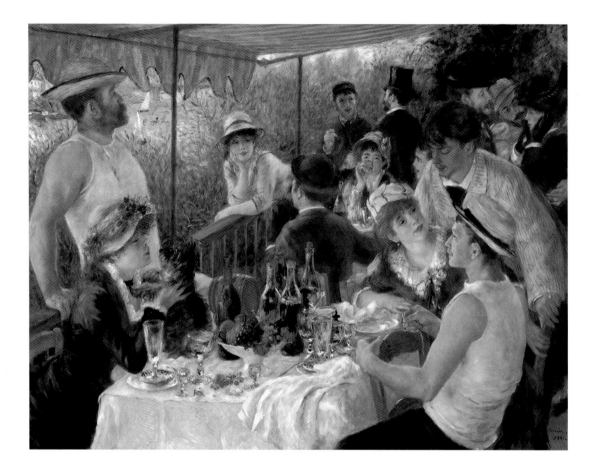

Renoir's three canvases of dancing couples of 1882–83 also give few anecdotal clues. Philippe Burty wrote of them in 1883:

> One could add to them the literary commentary so dear to the French imagination, but I can see in them only an art that is skilled in painting faces flushed with pleasure, relaxed by delicious fatigue, an art that makes clothing that is cut well and worn well seem elegant and distinguished.[80]

While two of these paintings are now titled *Dance in the Country* (Paris, Musée d'Orsay) and *Dance at Bougival* [FIGURE 50], Renoir further revealed his lack of

Figure 50
Pierre-Auguste Renoir.
Dance at Bougival,
1883. Oil on canvas,
181.8 × 98.1 cm (71⅝
× 38⅝ in.). Boston,
Museum of Fine Arts,
Picture Fund, 37.375.
Courtesy, Museum of
Fine Arts, Boston.

concern for specific readings by regularly changing their titles or permitting them to be changed, despite the significance in contemporary writing of the distinction between Bougival, with its entertainments, and the "true" countryside. Moreover, a drawing based on *Dance at Bougival* was also used as an illustration for a story by Renoir's friend Paul Lhote that was set at the Moulin de la Galette in Montmartre.[81]

Renoir produced a final variant on the theme of *La Promenade* in 1883—a drawing [FIGURE 51] published in the magazine *La Vie moderne* as an illustration to a story by his younger brother, Edmond, entitled "L'Étiquette." The drawing has no title and does not illustrate any specific episode in the story, which is set at Bordighera, on the Mediterranean coast just over the Italian border from Menton. In the drawing it is the woman who leads the man up the slope; in this sense the image is far more risqué than *La Promenade*, since stock gender roles are so blatantly reversed. However, because it was reproduced in a magazine and not presented as a work of fine art, its imagery was unproblematic.

Renoir's later art systematically avoids narrative; his figure groupings are presented as parts of the seamless whole that forms the picture, without hint of physical or psychological interplay that might suggest the slightest disturbance of their equilibrium. Late in his life Renoir told Georges Besson: "What we wanted in our pictures in 1874 was *des accords gais*—life without literature."[82] There is a fascinating linguistic ambiguity in this formulation: should the *accords* be understood in terms of the social relationships depicted or the harmonies of color, tone, and touch used to depict them? In Renoir's later work he sought to make these two types of *accords* one, to re-create his image of a serene universe in paintings that were replete and harmonious from edge to edge, top to bottom.[83]

La Promenade cannot simply be explained in these terms. As we have seen, its figures and setting linked it closely to contemporary social and moral debates, and the action itself is not seamless: the viewer is invited to interpret the play of gestures, although no clear outcome to the action is indicated. On the borderline between popular illustration and fine art painting, its imagery would have resonated with familiar narratives of courtship and seduction, while its status as a fine art painting and its "artistic" technique would have

marked it out as an object from high culture, appealing to an enlightened elite. In a sense this paradoxical combination sums up the early history of Impressionism—an utter rejection of the idealist world of academic art, coupled with an appeal to a new elite that placed the highest value on the virtuoso transformation of the individual's visual *sensations* into fine art.

Figure 51
Pierre-Auguste Renoir. Untitled drawing, 1883. Medium, size, and present whereabouts unknown. Published in *La Vie moderne* (29 December 1883), p. 835.

NOTES

1 The painting was lot 33 in the sale of Gustave Goupy at the Hôtel Drouot, Paris, 30 March 1898, and was purchased by Durand-Ruel for 1,050 francs. He sold it for 12,000 francs to the Berlin dealer Paul Cassirer in 1908. The work passed through the hands of the collector Bernhard Kohler, the dealer Paul Rosenberg, the collectors Nate B. and Frances Spingold, and the Seito Collection before its acquisition by the British Rail Pension Fund in London in the late 1970s. The picture was placed on loan at the National Gallery of Scotland, Edinburgh, for a number of years before being sold by the Pension Fund at Sotheby's, London, on 4 April 1989, lot 6; the J. Paul Getty Museum was the purchaser.

2 *Renoir Centennial Loan Exhibition*, exh. cat. (New York, Duveen Galleries, 1941), p. 119.

3 Ambroise Vollard, *La Vie et l'oeuvre de Pierre-Auguste Renoir* (Paris, 1918), reprinted in Ambroise Vollard, *En écoutant Cézanne, Degas, Renoir* (Paris, 1938); Jean Renoir, *Renoir* (Paris, 1962). All translations are by the author.

4 The classic account is John Rewald, *The History of Impressionism*, 4th ed. (New York and London, 1973); for a recent presentation of much the same selection of paintings, see Gary Tinterow and Henri Loyrette, *Origins of Impressionism*, exh. cat. (New York, Metropolitan Museum of Art, 1994).

5 For a strongly argued recent presentation of this view, see Michael Fried, *Manet's Modernism: or, The Face of Painting in the 1860s* (Chicago, 1996).

6 See Louise d'Argencourt, "Bouguereau and the Art Market in France," in *William Bouguereau*, exh. cat. (Montreal Museum of Fine Arts and Hartford, Wadsworth Atheneum, 1984), especially pp. 99–101.

7 See Patricia Mainardi, *Art and Politics of the Second Empire: The Universal Exhibitions of 1855 and 1867* (New Haven and London, 1987), pp. 154–74, 187–93.

8 Olivier Merson, *La Peinture en France: Exposition de 1861* (Paris, 1861), pp. 229–30. For similar verdicts, see Maxime du Camp, *Le Salon de 1857* (Paris, 1857), p. 51; Ernest de Toytot, "L'Art indépendant et le Salon de peinture en 1866," *Le Contemporain* (May 1866), p. 917; Ernest Chesneau, *Les Nations rivales dans l'art* (Paris, 1868), pp. 241–44; Raoul de Navery, *Le Salon de 1868* (Paris, 1868), p. 5.

9 Marius Chaumelin, "Salon de 1868: V," *La Presse* (29 June 1868).

10 This was first identified by Anne Distel in *Renoir*, exh. cat. (London, Hayward Gallery, and Boston, Museum of Fine Arts, 1985), pp. 179–80.

11 Barbara Ehrlich White, in *Renoir: His Life, Art and Letters* (New York, 1984), pp. 36–37, has suggested that this work should be seen as a pair to *Woman of Algiers*, a canvas of virtually the same size. However, the tonality of the two is markedly different, and the technique of *A Nymph by a Stream* may suggest a date of circa 1871–72 (on this, see John House, *Renoir: Master Impressionist*, exh. cat. [Queensland Art Gallery/Art Exhibitions Australia Limited, 1994], p. 58).

12 On Lise, see Douglas Cooper, "Renoir, Lise and the Le Coeur Family: A Study of Renoir's Early Development," *Burlington Magazine* (May, September–October 1959). Barbara Ehrlich White has recently suggested, in *Impressionists Side by Side* (New

York, 1996), p. 85, that the models for *La Promenade* were Claude Monet and his companion, Camille Doncieux. However, the man, clearly beardless, bears little resemblance to Monet, who was already fully bearded by 1870, and the features of the woman are not indicated with enough precision for her to be securely identified as Camille. Lise was the model for virtually all of Renoir's female figures at this time.

13 Marius Chaumelin, "Salon de 1870: VII," *La Presse* (17 June 1870). He also compared the picture with Courbet's "celebrated *Bathing Woman*," presumably referring to the Montpellier *Bathing Women*.

14 On the parodic aspects of Courbet's Salon paintings, see John House, "Courbet and Salon Politics," *Art in America* (May 1989), pp. 160–72, 215.

15 Zacharie Astruc, "Salon de 1868 aux Champs-Élysées: Le grand style—II," *L'Étendard* (27 June 1868).

16 Paul Mantz, "Salon de 1868: I," *L'Illustration* (9 May 1868), p. 299.

17 Pictures subtitled "study" (*étude*) were unusual but not unknown at the Salon in these years. Two examples will show how differently the term might be used. In 1863 Jean-Baptiste-Camille Corot exhibited two small, informal landscapes, *Étude à Ville-d'Avray* and *Étude à Méry*, together with a picture titled *Soleil couchant*; in 1868 Jules Lefebvre showed an elaborately finished canvas of a reclining nude as *Femme couchée; étude*, presumably because the picture was a modern life subject without any mythological references (reproduced, although without reference to its appearance at the 1868 Salon, in Hollis Clayson, *Painted Love: Prostitution in French Art of the Impressionist Era* [New Haven and London, 1991], p. 36).

18 Letter from Renoir to Bazille, autumn 1869, in Gaston Poulain, *Bazille et ses amis* (Paris, 1932), pp. 156–57. *The Engaged Couple* was so titled on its first exhibition early in the twentieth century. The models have traditionally been identified as the painter Alfred Sisley and his fiancée, but it has recently been suggested that this was the painting put on show at Carpentier's and that the female model was Lise Tréhot (see *Renoir* [1985], pp. 188–89). However, since the scene is presented as a genre painting, not a portrait, the identity of the models is less significant than the roles they play.

19 On auctions, see John House, "Framing the Landscape," in *Landscapes of France/Impressions of France*, exh. cat. (London, Hayward Gallery, and Boston, Museum of Fine Arts, 1995), p. 26.

20 On Deforge, see Nancy Davenport, "Armand-Auguste Deforge, an Art Dealer in Nineteenth-Century Paris and 'La Peinture de Fantaisie,'" *Gazette des beaux-arts* 101 (February 1983), pp. 81–88 (on Carpentier, see pp. 84, 88, note 8).

21 Robert L. Herbert, in *Impressionism: Art, Leisure, and Parisian Society* (New Haven and London, 1988), pp. 190–92, has noted the eighteenth-century echoes in paintings such as *La Promenade*.

22 Théophile Gautier, "La Rue Laffitte," *L'Artiste* (3 January 1858), p. 10.

23 Letter from Bonvin to Martinet, 22 April 1861, in Étienne Moreau-Nélaton, *Bonvin raconté par lui-même* (Paris, 1927), pp. 58–59.

24 See letters from Boudin to his brother, 8 December 1866, and to M. Martin, 18 January 1869, in G. Jean-Aubry, *Eugène Boudin d'après des documents inédits* (Paris, 1922), pp. 63, 72.

25 For the Monet, see Tinterow and Loyrette, *Origins of Impressionism*, p. 440; for Pissarro's *The Versailles Road at Louveciennes*, purchased by the American agent George Lucas from Martin in January 1870, see *Pissarro*, exh. cat. (London, Hayward Gallery, and Boston, Museum of Fine Arts, 1980), p. 80.

26 See John House, *Monet: Nature into Art* (New Haven and London, 1986), pp. 40–43.

27 A virtual manifesto was published for Durand-Ruel's new gallery in *Revue internationale de l'art et de la curiosité*, a magazine directed by Durand-Ruel himself, although this was not noted in its pages; see Jacques Raffey, "Galerie de M. Durand-Ruel," *Revue internationale de l'art et de la curiosité* 2 (15 December 1869), pp. 478–85.

28 See Jane Mayo Roos, *Early Impressionism and the French State (1866–1874)* (Cambridge and New York, 1996).

29 Chaumelin, "Salon de 1868: V."

30 Jules Castagnary, *Salons (1857–1879)* (Paris, 1892), vol. 1, pp. 364–65.

31 Théodore Duret, "Salon de 1870," in *Critique d'avant-garde* (Paris, 1885), pp. 19–20, first published in *L'Électeur libre* (May and June 1870).

32 L. Laurent-Pichat, "Salon de 1870 (11e article)," *Le Réveil* (4 June 1870).

33 These debates were brought into focus by the much-discussed *Opinion de M. le Procureur Dupin sur le luxe effréné des femmes*, a speech delivered in the Senate in 1865, reprinted in Ernest Feydeau, *Du luxe, des femmes, des moeurs, de la littérature et de la vertu* (Paris, 1866), pp. 195–204. Dupin's homily elicited responses from many points of view, among them Feydeau's, whose book is from the perspective of a fashionable *boulevardier*, and Olympe Audouard's, whose *Le Luxe des femmes: Réponse d'une femme à Monsieur le Procureur Général Dupin* (Paris, 1865) is from the perspective of a feminist *femme du monde*.

34 Castagnary, *Salons (1857–1879)*, vol. 1, pp. 364–65. Although the models for *The Balcony* have been identified as the painters Berthe Morisot and Antoine Guillemet and the violinist Fanny Claus, the fact that they are not named in the painting's title means that this played no part in the way in which the work was viewed at the Salon, except among the small circle of Manet's friends.

35 Antonin Proust, "Édouard Manet (Souvenirs)," *Revue blanche* (1 March 1897), pp. 202–3.

36 Marius Chaumelin, "Le Salon de 1869: V," *L'Indépendance belge* (21 June 1869); Edmond Duranty, "Le Salon de 1870: III," *Paris-Journal* (5 May 1870).

37 Castagnary, *Salons (1857–1879)*, vol. 1, pp. 364–65; Paul Mantz, "Le Salon de 1868: 2e et dernier article," *Gazette des beaux-arts* (July 1869), p. 13.

38 Paul Mantz, "Salon de 1868: V," *L'Illustration* (6 June 1868), p. 362.

39 Théophile Thoré, *Salons de W. Burger, 1861 à 1868* (Paris, 1870), vol. 2, pp. 531–32, first published in *L'Indépendance belge* (29 June 1868).

40 For further discussion of the illegibility and moral uncertainties of these pictures, see John House, "Manet's Naïveté," in *The Hidden Face of Manet*, supplement to *Burlington Magazine* 128, no. 997 (April 1986), pp. 1–19, and John House, "Social Critic or Enfant Terrible: The Avant-garde Artist in Paris in the 1860s," in *Actes du XXVIIe congrès international d'histoire de l'art: L'Art et les révolutions*, section 2: Changements et continuité dans la création artistique des révolutions politiques, ed. Klaus Herding (Strasbourg, 1992), pp. 47–60.

41 Charles Baudelaire, "Le Peintre de la vie moderne," *Le Figaro* (26, 29 November, 3 December 1863), text written circa 1859–60 and reprinted many times.

42 For a valuable discussion of genre painting in the context of censorship, see Leila W. Kinney, "Genre: A Social Contract?" *Art Journal* 46, no. 4 (winter 1987), pp. 267ff. See also John House, "Manet's *Maximilian*: Censorship and the Salon," in Elizabeth C. Childs, ed., *Suspended Licenses: Essays in the History of Censorship and the Visual Arts* (Seattle, 1997).

43 For a more detailed critique of the view that *Interior* should be seen as an illustra-

tion to a literary text, see John House, "Degas' 'Tableaux de Genre,'" in Richard Kendall and Griselda Pollock, eds., *Dealing with Degas* (London, 1992). For a persuasive elaboration of a similar argument, see Susan Sidlauskas, "Resisting Narrative: The Problem of Edgar Degas's *Interior*," *Art Bulletin* 75, no. 4 (December 1993), pp. 671–96.

44 See Nicholas Green, *The Spectacle of Nature: Landscape and Bourgeois Culture in Nineteenth-Century France* (Manchester, 1990), pp. 118–19, 167–81.

45 See, for instance, Eugène Briffault, *Paris dans l'eau* (Paris, 1844), pp. 26–27, and Oscar Commettant, *En vacances* (Paris, 1868), pp. 179–87. Both of these writers use the imagery of the "siren."

46 Émile de Labédollière, *Histoire des environs du nouveau Paris* (Paris, 1861), pp. 136–37.

47 Zacharie Astruc, "Le Salon de 1870, septième journée," *L'Écho des beaux-arts* (19 June 1870).

48 Letter from Madame Morisot to Berthe Morisot, 19 August [1868?], in Denis Rouart, ed., *The Correspondence of Berthe Morisot*, new edition introduced by Kathleen Adler and Tamar Garb (London, 1986), p. 29.

49 Victorien Sardou, "Louveciennes-Marly," in *Paris-Guide, par les principaux écrivains et artistes de la France* (Paris, 1867), vol. 2, pp. 1456–57, quoted in T. J. Clark, *The Painting of Modern Life: Paris in the Art of Manet and His Followers* (New York, 1984), p. 298, note 7. "The Environs of Paris," chapter 3 of this book, is the most searching and thoughtful analysis of the imagery of this region.

50 Letter from Monet to Bazille, 25 September 1869, in Daniel Wildenstein, *Monet: Biographie et catalogue raisonné* (Lausanne and Paris, 1974), vol. 1, p. 427, letter 53.

51 For instance, see Herbert, *Impressionism*; Paul Hayes Tucker, *Monet at Argenteuil* (New Haven and London, 1982); and

Richard R. Brettell, *Pissarro and Pontoise* (New Haven and London, 1990).

52 Astruc, "Salon de 1868 aux Champs-Élysées."

53 In 1886 Renoir's friend Catulle Mendès published *Les Îles d'amour*, a volume of evocative essays that included one on La Grenouillère. Such amorous escapes to the islands in the Seine were also a central image in the stories of Guy de Maupassant, notably in "Une Partie de campagne" (later the basis of a film by Jean Renoir) and "La Femme de Paul" (set at La Grenouillère), both written around 1880.

54 Théophile Gautier *fils*, "Le Salon de 1867 (5e)," *L'Illustration* (25 May 1867), p. 326.

55 Adolphe Joanne, *Les Environs de Paris illustrés* (Paris, 1881 [preface dated 1877]), pp. xxv–xxvi.

56 Duret, "Salon de 1870," in *Critique d'avant-garde*, p. 19.

57 Castagnary, "Philosophie du Salon de 1857," reprinted in *Salons (1857–1879)*, vol. 1, pp. 23, 33–42.

58 It has been suggested that the dog—a "griffon"—that accompanies the woman indicates, by contemporary conventions, that she is a prostitute. See Richard Thomson, "Les Quat' Pattes: The Image of the Dog in Late Nineteenth-Century French Art," *Art History* 5, no. 3 (September 1982), p. 328.

59 These paintings are reproduced in Christopher Wood, *Tissot* (London, 1986), pp. 47, 49.

60 Renoir, *Renoir*, p. 71; see also Albert André, *Renoir* (Paris, 1928), p. 32. However, in 1883 Renoir did exhibit a painting with the title *Jeune femme pensive* in his one-man show at Durand-Ruel's gallery in Paris. This work can probably be identified with the 1879 painting now known as *The Dreamer* (Saint Louis Art Museum).

61 *Renoir Centennial Loan Exhibition*, p. 119.

62 An example of such a pornographic image is a small oil painting, attributed to Achille Devéria, entitled *The Interrupted Walk in the Woods* (Hamburg, Museum des erotischen Kunst). See Museum der erotischen Kunst, *Five Hundred Years of Erotic Art* (Hamburg, 1992), pp. 76–77.

63 Zacharie Astruc interpreted the picture in terms of expectation; see Astruc, "Salon de 1868 aux Champs-Élysées."

64 Alphonse de Calonne, "Beaux-Arts: Salon de 1853," *Revue contemporaine* 8 (1 June 1853), p. 153.

65 See, for example, Alfred Delvau, *Les Plaisirs de Paris: Guide pratique et illustré* (Paris, 1867), pp. 193–94, 263–67.

66 Letter from Monet to Bazille, 25 September 1869, in Wildenstein, *Monet*, vol. 1, p. 427, letter 53.

67 Philippe Burty, "Le Salon: X," *Le Rappel* (15 June 1870).

68 Astruc, "Salon de 1868 aux Champs-Élysées"; Castagnary, *Salons (1857–1879)*, vol. 1, p. 313.

69 Zacharie Astruc, "Le Salon de 1870—4e journée," *L'Écho des beaux-arts* (29 May 1870); Philippe Burty, "Le Salon, III: Les Portraitistes," *Le Rappel* (11 May 1870); Duranty, "Le Salon de 1870: III."

70 For the seminal discussion of the subjectivity of the *sensation* and the *impression*, see Richard Shiff, *Cézanne and the End of Impressionism* (Chicago, 1984), especially pp. 14–26, 187–94.

71 Philippe Burty's preface to the catalogue of the auction sale organized by Renoir and some of his colleagues in March 1875 (the nearest thing to a manifesto for the Impressionist group) emphasizes the relationship between their "rapid and subtly colored" handling and their view of the world, "like small fragments of the mirror of universal life [*la vie universelle*]"; see Philippe Burty, preface to *Tableaux et aquarelles par Claude Monet, Berthe Morisot,*

A. Renoir, A. Sisley, sale catalogue (Paris, Hôtel Drouot, 24 March 1875), reprinted in Denys Riout, ed., *Les Écrivains devant l'impressionnisme* (Paris, 1989), pp. 47–49.

72 The caricature by Bertall [Charles-Albert d'Arnoux], first published in *Le Journal amusant* (21 May 1870), is reproduced in Rewald, *The History of Impressionism*, p. 196.

73 See Marcel Crouzet, *Un Méconnu du Réalisme: Duranty* (Paris, 1964), pp. 234–58, 287–97.

74 Renoir, *Renoir*, p. 64.

75 Renoir's father was a tailor, whose trade was threatened by mechanization, and Renoir's own first trade, as a porcelain painter, was undermined by the development of machine-made products. For further discussion of his social background, see John House, "Renoir's Worlds," in *Renoir* (1985), pp. 11–18.

76 Ibid., pp. 11–13.

77 See Jerrold Seigel, *Bohemian Paris: Culture, Politics and the Boundaries of Bourgeois Life*, 1830–1930 (New York, 1986). For a contemporary anatomy of the "bohemian" position, see *Paris-Bohême*, par les auteurs des Mémoires de Bilboquet [i.e., Taxile Delord, Arnould Frémy, and Edmond Texier] (Paris, 1854).

78 Renoir, *Renoir*, pp. 68, 179.

79 Georges Rivière, "Les Enfants dans l'oeuvre et la vie de Cézanne et de Renoir," *L'Art vivant* (1 September 1928), p. 673.

80 Philippe Burty, "Les Peintures de M. P. Renoir," *La République française* (15 April 1883).

81 For details of these titles, see *Renoir* (1985), pp. 235–38.

82 Georges Besson, *Renoir* (Paris, 1929), p. 4.

83 See John House, "Renoir and the Earthly Paradise," *Oxford Art Journal* 8, no. 2 (1985), pp. 21–27.

ACKNOWLEDGMENTS

My enthusiasm for *La Promenade* was sparked by John Walsh, then Curator of European Paintings at the Museum of Fine Arts, Boston, when we were colleagues in the team preparing the 1985–86 Renoir retrospective exhibition. I did not have the chance to write about *La Promenade* in that exhibition catalogue, and I am very happy finally to have this opportunity to explore it—and at far greater length—after its acquisition by the museum of which he is now director.

Much of the initial research that underpins this book was undertaken while I held a British Academy Research Readership in 1988–90; I take this opportunity to acknowledge my gratitude to the British Academy for this period of leave, during which I was able to broaden and deepen my understanding of the Paris art world in the Second Empire. Sabbatical leave at the Courtauld Institute of Art, University of London, enabled me to complete the research and prepare the final text.

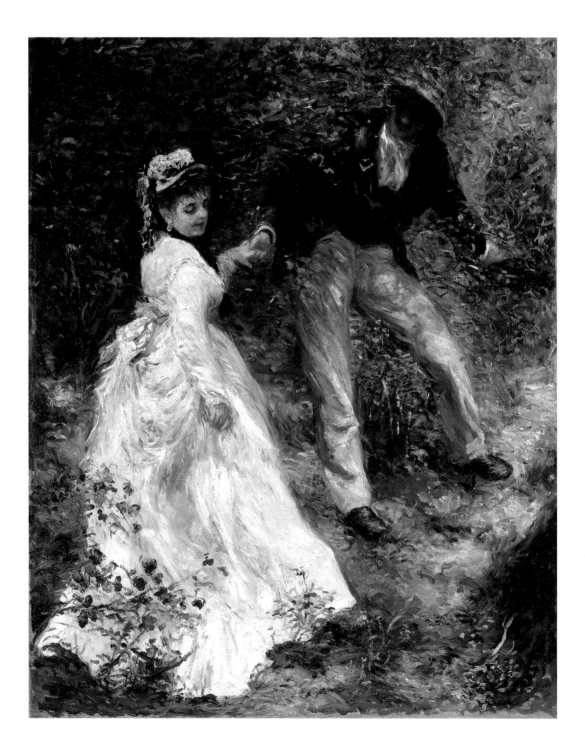